LIAM GILLICK
THE WOOD WAY
Whitechapel Art Gallery
2002

Texts by
Daniel Birnbaum
Iwona Blazwick
Jeremy Millar
Anthony Spira and Liam Gillick
Lawrence Weiner

and responses to questions from
Lionel Bovier, Jan Estep, Annie Fletcher,
Mark Francis, Søren Grammel, Akiko Miyake
and Haegue Yang

TWOTHOUSANDANDTWO, 2001
New year card. Galerie Hauser & Wirth & Presenhuber, Zurich

zweitausendundzwei zweitausendundzwei duemiladue duemiladue deux deux mille deux deux mille duamillidus duamillidus two thousand and two two thousand and

CONTENTS

4.
INTRODUCTION
Iwona Blazwick

7.
MINIMA MORALIA: LIAM GILLICK
AND THE FUTURE OF THE PAST
Daniel Birnbaum

10.
WE ARE ABLE TO WALK ON AIR,
BUT ONLY AS LONG AS OUR
ILLUSION SUPPORTS US
Jeremy Millar

14.
SPECULATION AND PLANNING
Liam Gillick with Anthony Spira

22.
IS GILLICK BEGGING THE QUESTION?
Lawrence Weiner

24.
THE WOOD WAY INSTALLATION SHOTS

40.
LIST OF WORKS

41.
SOME WORKS, PROJECTS
AND GRAPHICS 1998 - 2002

80.
THE SEMIOTICS OF THE BUILT WORLD
Liam Gillick

90.
BIOGRAPHY

96.
ACKNOWLEDGEMENTS

INTRODUCTION
Iwona Blazwick

THE WOOD WAY is a literal translation of the German expression 'Holzweg'. It derives from the word for a path cut by foresters and means that you have unwittingly taken a wrong turn and lost yourself in metaphorical thickets. In many ways the British artist Liam Gillick wilfully manoeuvres his readers, viewers, collaborators and discursants into departing from familiar routes to enter a maze of tangential and unexpected places, into what he has called a 'no place'.

This place is not however as abstract as it sounds. For all the conceptual speculation that Liam Gillick's practice has engendered, his work has a very specific procedural and material base.

This publication accompanies an exhibition which brings together works the artist produced at the turn of the 20th and 21st centuries. THE WOOD WAY brings together a selection of some twenty works from two ongoing series - THE WHAT IF? SCENARIO and DISCUSSION ISLAND.

These bodies of work are interrelated and deploy some consistent formal strategies. Gillick has an established reputation as a writer – he uses text to elaborate on his own work, to analyse the ecosystems of art and, in his narratives and scripts, as an art form in its own right. One critical aspect of his material practice lies therefore in how he names his works.

The title of an individual piece often combines an event, a location, an act and an object - for example, DISCUSSION ISLAND DIALOGUE PLATFORM. Gillick typically selects nouns that also function as verbs/activities, and objects that also function as metaphors. The word 'discussion' might be replaced by 'regulation', 'consultation', 'delay' or 'resignation', nouns which define both actions and events. They are words which also carry strong connotations of the culture of management, of a discourse which is reasoned, inclusive, democratic, liberal yet nonetheless bureaucratic and strategic. He goes on to marry a managerial signifier with an architectural component such as screen, platform or tank - words which also function as metaphors. To transpose Rosalind Krauss writing about a list of actions made by Richard Serra, Gillick's titles 'are themselves the generators of art forms: they are like machines which, set into motion, are capable of constructing a work.'

The works themselves can be described as structures which are in some way architectural. Their scale, which operates between 2.4 and 3.6 metres, seems devised not so much in relation to the body as in relation to a built interior - not individuated domestic rooms, but rather communal 'white collar' work spaces, such as offices, meeting rooms or lobbies. Gillick's structures work in both two and three dimensions. Typically, while taking up a commanding position in a room, they also appear flat. Anodised aluminium frames, arranged in extended lateral or vertical grids hold sheets of Plexiglas. Brightly coloured with intense primaries or vivid pastels, Gillick's coloured panels are resolved into bands by the rectilinear configurations of the frames, juxtaposed and rationalised with as much precision as a Mondrian or indeed a Judd. Like Judd, Gillick has been drawn to the industrially produced, thoroughly even colours of Plexiglas, colours which are not attached or applied to its surface but which are part of the material itself. By turns transparent and opaque his monochromatic bands are dazzling; they bounce reflections, or throw chromatic light on their surroundings with all the transformative hue of a rose coloured 'Poussin glass'. Like stained glass windows they carry intimations of transcendence; and like Modernist housing developments they speak of an abstract and therefore putatively universal language of optimism. There is no sense of a compositional hierarchy, rather a rhythm of equivalence – a blue recedes, an orange advances, but each is repeated, given equal yet exuberant status as in a piece of systems music. All this exhilaration is however, kept firmly in check, regimented and confined by the neat geometries of Gillick's aluminium systems.

This sense of containment and order is itself unstable. Understood in relation to his drawings, the 'outlines' of Gillick's aluminium structures both confine and propose, their linearity reminiscent of a diagram, their movable, lightweight structure suggesting a temporary presence, or a model. His use of computer aided drawing, off the peg colours and predetermined measurements from graphic design packages is combined with a viral attitude which Gillick adopts to trigger the irrational, accidental potential of these technological tools, releasing their organic potential.

As well as operating on a vertical, retinal level, his structures generate a spatial, phenomenological experience. They may float above the spectator, creating a suspended ceiling that does not necessarily need to be seen to exert its presence. His 'screens' and 'platforms' might clad, interrupt or encase a space and by extension our own presence. They encourage an intuitive bodily perception of movement through navigation and of perception through looking not just ahead but above, below and from the corner of the eye. Gillick choreographs spaces to make our relation to them per-formative - they might equally frustrate with the cul-de-sac or beckon with a resting place, seduce with a colour or clue, or obscure with a barrier or reflection.

In Gillick's practice multi-valence as attitude, becomes form. A 'screen' is an architectural structure; but it can also be a surface on which to project a film, a shield against danger, a form of mask or concealment, a medical test, a sorting procedure and a security operation. In the deployment of his structures in a gallery or other public building, Gillick creates a sculptural form which can convey all these meanings.

He also uses structure, colour, location and style to activate histories of modern and contemporary culture and art. Yet his is no post-modern, historical eclecticism; rather he reflects the archeologies of our times, and how the ideologies of the recent past are refracted through and distorted by the present. His perspective is both broadly social and openly personal. Gillick pays tribute to the influence Conceptual art, Modernist architecture, film makers such as Stanley Kubrick or writers such as J.G. Ballard have had on his practice.

Gillick's platforms, screens and 'think tanks' are also as much about the here and now and about potential futures as they are about the past. In commentaries about his practice, the word 'utopia' figures heavily. Gillick however has returned to the true definition of the word as 'no place'. He has also spoken of his interest in a middle ground and in what happens not at the official forefront of history, but behind the scenes or perhaps more accurately in the underground tunnels of officialdom. The American author, Don DeLillo has suggested that our contemporary passion for conspiracy theories is in part a reaction to the secularisation of our age – we fantasise about an all seeing, all knowing yet invisible authority, as powerful and ruthless as the old Jehovah. Yet in reality social and political upheavals are triggered by the chance alignments of individuals and events which are neither co-ordinated nor inevitable.

Gillick sets up such possibilities – without prescribing whether their outcomes are for the good or the bad. In his labyrinthine construction, THE WOOD WAY he has created opportunities for us to meet, to reclaim the idea of discussion, consultation, renovation or delay – for us to become protagonists in modelling possible futures.

Liam Gillick's vision has provided the framework for this publication; for an installation at the Whitechapel Art Gallery which is both a survey and a new work of art in its own right; and for the gallery's own discursive spaces – the café and the auditorium. Characteristically he has worked collaboratively. Joining him in this project is the curator Anthony Spira, writers Daniel Birnbaum and Jeremy Millar, artist Lawrence Weiner and the designer Adam Hooper. We greatly appreciate their contribution to this project and that of all the lenders to the exhibition. We are grateful to the Corvi-Mora Gallery in London and to Schipper & Krome, Berlin, Eva Presenhuber, Zurich, Javier Lopez in Madrid, Florence Bonnefous and Edouard Merino in Paris and Casey Kaplan, New York who enabled us to realise the full ambitions of THE WOOD WAY. Finally, our thanks to Liam Gillick who has been an influential and enabling force in the London and European art scene for over a decade and whose rich and generous work makes such a powerful contribution to the theory and practice of sculpture, architecture, design and art writing today.

CONSIENS LOBBY, 2001
Elevation of hanging structure, Telenor, Oslo

MINIMA MORALIA: LIAM GILLICK
AND THE FUTURE OF THE PAST
Daniel Birnbaum

'Droll thing life is – that mysterious arrangement of meticulous logic for a futile purpose. The most we can hope for it is a little knowledge of ourselves, that comes too late.'
JOSEPH CONRAD

Too late. We don't know who we are, and we don't know the meaning of what we do. And when we realise (given that this ever happens), it's already too late. Can this dismal logic of psychological delay be transplanted to the scene of cultural history, i.e. to the level of the collective? In an essay from the early 1990s, Liam Gillick writes, 'There are various points when a rather utopian notion of potential takes over and temporarily there appears to be a consensus, an illusory set of situations that appears to concern us all.' This rather dry statement may be a good description of what more optimistic writers have called moments of 'social possibility' or even of 'revolutionary change.' In Gillick's recent book FIVE OR SIX, 2000, I find three images that open the section STOCKHOLM TO KITAKYUSHU which clearly relate to such a 'utopian potential.' They are from the modern parts of central Stockholm: a glass sculpture that stands on the Plaza Sergels Torg, the Cultural Center (which actually formed the prototype for Centre Pompidou), and the façade of a tall building on the other side of the plaza.

These three images represent a glimpse from a political situation of hope which lies just a generation away. What was Modernism? In Sweden an unusually clear view can be obtained, because here Modernism was not primarily concerned with novels or philosophical works. Such things did of course exist, but far more conspicuous was the construction of society itself, carried out with a level of consistency unmatched in the West – a construction that affected all inhabitants and virtually all aspects of life. The latest to

emphasise the exceptional nature of the Swedish model – and the consequences it has for architecture and city planning – is Peter Hall. In CITIES IN CIVILISATION he contends: 'But Sweden went further and more consistently down the road than any other country; and, not only was the system forged in the national institutions located in the country's capital, but the city itself came to be seen as the living embodiment, the showcase of a society they sought proudly to create as a model for the world. Though it had competitors, in the late 1950s and early 1960s it became known world wide as the quintessence of a social philosophy, realised on the ground. Its apartment towers, grouped around its new subway stations and shopping centres, impeccably designed and landscaped, became an object of pilgrimage for informed visitors all over the world.'

Just three photos and the picture is complete: Gillick's three fragments are the archetypal elements of this utopia. When Hall includes Sweden's capital in his comprehensive exposé of exemplary cities alongside Athens, Florence, London, New York, Tokyo, and Los Angeles – it is not because Stockholm, relatively modest in size, is a true metropolis, but clearly for other, more ideological reasons. This city is an extreme creation, which realised a clear political vision. More than any other city, Stockholm around 1960 embodied the European welfare state as a modern utopia. No one in this part of the world needed to be in doubt as to the meaning of Modernity; the world's most developed welfare state was not an evasive phenomenon. 'The great experiment did not quite work out as planned,' concludes Hall at the end of his exposé. What happened then? Today, Sergels Torg – that central Stockholm Plaza that was designed by Victor Vasarely – is the place to go if you're looking for heroin.

Another scenario: it's the late 1970s, it's a foggy night. It's autumn or maybe already winter. The brightly illuminated windows shine in suburbia. The buildings are too far away for any human traits to be visible. A statement about one of the films reads: 'The end of the 1970s was a time of intensified programs for urbanisation and territorial landscaping in France. However, these subsidised Public Housing Projects ended up being an architectural and

social failure. Except for a few rare situations, there was never any attempt to represent this period of time. In addition nobody took responsibility for the failure.' A statement about another film contends: 'The film frames an urban landscape that we can easily date from the same period, the end of the 1970s. . . Set on a piece of municipal ground with a block of flats in the distance, the scene is never viewed in daylight.' What message do these films convey, what information does the artist communicate? Clearly they are by the same artist, no?

Actually they are not. LES GRAND ENSEMBLES, 2001 is by Pierre Huyghe and CREDITS, 2000 by Philippe Parreno. These are two artists who have often collaborated with each other and with many others, including Liam Gillick, but in this case it's a question of individual works – and in spite of obvious similarities, the works on closer inspection display distinct traits. In both cases the works are about the processes of collective memory, and in both films the era remembered is the very late 1970s, when the failures of the Public Housing Projects become abundantly clear. However, the tools deployed for realising the recollection differ: in Parreno's case the soundtrack is by AC/DC lead guitarist Angus Young, in Huyghe's case it is by Pan Sonic and Céderic Pigot Randomly. Parreno stresses the collaborative aspect not only of the production itself (Inez van Lamsweerde, Vinoodh Matadin, M/M etc.), but also of the process of recollection: 'The film is the product of an investigation, co-ordinating different points of view.' The title CREDITS is really an abbreviation for the full list of contributors. But what is the status of the imagery brought about by such a collective process? Huyghe discusses the problem of recollection in very similar terms, and concludes: 'The image is not real. . . It is not a recreation, and it is definitely not a fictional moment. Instead it is a collective memory that constitutes an imaginary object.' Parreno and Huyghe clearly share Gillick's interest in those lost scenarios – urban, architectural, political – that once expressed a certain social optimism, even a vision of the future, but which later was to be transformed into something entirely different. 'Should the future help the past?', asks Gillick. One thing seems clear: a little help wouldn't hurt. Another question is: will it?

Social progress, urban planning, dystopia. Gillick's work PAIN IN A BUILDING, 1999, a two-projector slide sequence accompanied by ambient music, is of relevance here: '80 slides and 4 sound tracks form a location shoot for a potential movie to be written by Liam Gillick and Thomas Mulcaire, directed by Philippe Parreno and produced by Anna Sanders Films, Paris. The images were taken at Thamesmead in South London. The construction of Thamesmead began in the late 1960s and formed the location for the film CLOCKWORK ORANGE. The film was pulled from distribution in Britain after only a short release period. Kubrick was concerned that the vision of Britain portrayed in the film would encourage violence and social unrest.' Do Gillick's screens, platforms and filters produce zones for hopeful reflection or of elegant resignation? Take the practical PROTOTYPE DESIGN FOR CONFERENCE ROOM (1999) produced to host a symposium on art criticism. What is the temporality of this space: are we heading towards the future or are we hurled back to times when the future looked much better?

So there are clearly two types of lobby. The problem is they look the same, and both are designed by Liam Gillick. In one of them you ponder how old utopias have turned into style on the one hand and into dismal social realities on the other. You feel a bit distressed, but the lobby has a calming quality. You can doze away with an old issue of WALLPAPER in your lap. In the other lobby you read Edward Bellamy's 1887 book LOOKING BACKWARDS and ponder whether its worth waking up the hero of the book who's been asleep since 1887 and is supposed to wake up in the year 2000. Then you realise that that was two years ago and that the future has already happened. That's when you reach for other books, maybe something by Karl Marx.

BARRED, 2001
Poster for Jannowitzbrücke area of Berlin

A bar is overlooked by an army check
is where people go to have a drink. It i
people are determined to stay late in c
make a point. They say that something
on here which is beyond an idea of co
they say their presence is a demonstra
new and old forms of social behavior,
also the demonstration of being in a b
which is normal on the inside and whic
like a concrete bunker from the outsid
are saying that the idea of a bar over-l
an army check-point is an essential
demonstration of play. It is an essentia
demonstration that you can't organize
forms of social organization. The bar s
resolutely silent; there is no music in tl
no records, only talking. It is not a plac
singing it is a place to demonstrate tha
can still play when other people try an

WE ARE ABLE TO WALK ON AIR BUT ONLY AS LONG AS OUR ILLUSION SUPPORTS US

Jeremy Millar

A– will put in his earphones, press a switch clipped to his lapel, and walk out onto the street.

The first Friday of every month (except January and August) A– will go into the company – a corporate consultancy – and then talk with a group of people about whatever interests him. It will start through B–, an old friend from university, one of the company's founders and directors, who is keen to encourage new forms of thinking within the company – this is, after all, what the consultancy encourages in its work for various corporations. B– will wonder whether this is something A– might be interested in, to the extent that it will pay well and A– needs the money. So, A– will show a film, or talk about a book, or an artist, or something more broadly socio-cultural, although he will never attempt to make it 'relevant' to the activities of the company, or useful in any obvious way (perhaps he is too interested in these things to make them merely useful). Not that this will seem to matter. They will like his approach, and they will like him.

A– will have been thinking about utopia for some time, although it will take a while before he begins to consider it as a possible subject for the group. The more that A– thinks about it, the more inescapable it will become, and the more difficult too. He will read in the newspaper that he is already living in utopia, courtesy of the very corporations for whom the consultants are working, and so perhaps they should be telling him what utopia is, but then A– won't need to know what utopia is to know that this isn't it. A– will not care much for the corporations, or even for the company he will visit (A– never considers that he really works for them) which is why he will simply talk about the things that interest him, without transforming them into a new organisational strategy, or a model for collaborative problem solving. That first afternoon A– will talk about the obliqueness

of Chinese philosophy, its poetry too, not that he knows a great deal about it but it will be the most esoteric subject that he can think of and A– will assume (correctly) that no-one else present will know much about it either. And so he will recite from THE BOOK OF SONGS, and not once mention the modern world. But in doing so, A– will leave the impression that there are meanings that can be taken from what he says – that just as Qu Yuan can talk of flowers and fragrant plants and yet refer to the virtues of the kingdom from which he had been banished, then so something meaningful might be taken from his words, something relevant, if only they can work it out. Which is what they will attempt to do over the following month, before A– comes again, to play the next part of his elegant game.

A– had read WALDEN 2 at university, while going through a phase of American Transcendentalism, and assumed it to be some form of sequel to Thoreau's famous account of the simple life by a pond in Massachusetts. It is not. In fact, B.F. Skinner's 1948 novel of a utopian community based upon his principles of Behaviourism – Skinner was Professor of Psychology at Harvard – seemed almost a rebuke of Thoreau's heroic individualism. The community's founder, Frazier, explains that, 'We chose our name in honour of Thoreau's experiment, which was in many ways like our own. It was an experiment in living…' albeit a very different form of living. Unlike Thoreau, the inhabitants of WALDEN 2 did not reject modern life and the technology that it brought with it: 'We look ahead, not backwards, for a better version.'

A– will be reminded of WALDEN 2 by an article written by an artist in PARKETT, a magazine that A– occasionally buys. A– will be intrigued by the artist's work, by the objects that he makes, the structures that he designs, the books that he writes, but most of all A– will be intrigued by the way that the artist positions himself between things, that is, in the middle of things and on the edges of things simultaneously. The artist's work often seems to be about control, albeit the soft controls of discussion, negotiation and debate, and the influence of environment upon those forms of control, and so it might come as little surprise that he has turned to Skinner's utopia of planning.

Unusually, Skinner's utopia is one of means, rather than ends. The ends, it assumes, are obvious, or at least, unspoken: what will be required is a means of bringing them about, and this can only happen through the shaping and control of human behaviour. So, this is what A– will talk to his group about, or rather, this is what A– will talk about while talking about the work of the artist.

That the artist will have an exhibition near the company's office, and relatively near his own apartment, will certainly have an influence on his decision. A– will leave a large apartment complex in the financial area and walk down through the City towards the gallery, Cardew playing on his minidisc. A– will walk through the lobby, through the reception area, and into the large gallery space. In front of him will stand a large slatted screen made of wide wooden planks, and from certain angles A– will look through the gaps to what lays behind, more screens, some of them Perspex, others wooden. As A– walks around, the room will seem to flicker, and A– will wonder whether there is some subliminal effect created by the constructions. A– will assume that there is, that the work is about subliminal and liminal effects. A– will walk around a little more and then may go up the stairs to the café for lunch.

A– will move his tray to one side and look across at the bookshop where A– often thinks of utopia, reminding himself to visit after leaving the gallery. A– will take out a folder of photocopies, his notebook, some papers downloaded from the internet and a couple

of books, all of them fringed by page markers or dashed in fluorescent ink. A– will notice that someone at a nearby table is reading the catalogue to the exhibition, and will wonder what is written inside. At the top of a page in his notebook A– will have copied out his working title from a book on Disneyland by E.L Doctorow (now there is a corporate utopia). A– will read through some of his notes before picking up a photocopied page from Huxley's ISLAND, a utopia that seems to share much with his earlier, more famous dystopia. One of the characters describes the effect of a drug, Moksha, which he has taken:

'Turning his head a little further to the left he was startled by a blaze of jewellery. And what strange jewellery! Narrow slabs of emerald and topaz, of ruby and sapphire and lapis lazuli, blazing away, row above row, like so many bricks in a wall of the New Jerusalem. Then – at the end, not in the beginning – came the word. In the beginning were the jewels, the stained glass windows, the walls of paradise. It was only now, at long last, that the word 'book-case' presented itself for consideration.'

The account will appear almost a description of some of the artist's screens – the mention of a book-case will be interesting too – although A– won't be sure how he can use it. Perhaps he will just leave it hanging there, like one of the artist's platforms, like a rhetorical device. Would A– be right in thinking that the artist's mother's maiden name is Huxley and that she might have claimed some distant familial connection to the author? A– will not be sure; perhaps it will just be wishful thinking, on the part of one or the other.

The screens will continue to flicker in his head, unstable, like his thinking, and the works to which they refer. Most of the time, Skinner's world will seem mean-spirited and vile. A– will

detest the disinterested bureaucracy that epitomises the WALDEN 2 community. He will flick to a page marked in the book:

'The actual achievement is beside the point. The main thing is, we encourage our people to view every habit and custom with an eye to possible improvement. A continuously experimental attitude towards everything – that's all we need. Solutions to problems of every sort follow almost miraculously.'

This is the managers' credo: to do, but with no thought as to what should be done. A– will picture himself sitting in the company meeting room, and will feel himself falling through space. Is there any virtue in what he is doing? Is there any virtue in what the other people there are doing?

A– will find a paper on Alasdair MacIntyre, a philosopher of ethics, on the internet, and will consider how it might relate to what he will do here, what he will think about. The work is forceful yet will both strengthen and weaken his resolve: strengthen because it will formulate some of the concerns A– feels, yet only vaguely acknowledges; weaken because he will fear that he does not have the moral courage to step back from what he will feel to be wrong. Many of the arguments made by MacIntyre seem to address Skinner's utopia directly, although no actual mention is made of it. One observation, particularly relevant now, is quoted at the beginning of the paper, that 'in our culture we know of no organised movement towards power which is not bureaucratic and managerial in mode and we know of no justifications for authority other than those couched in terms of instrumental effectiveness.' Exactly, Skinner would no doubt respond. Precisely, MacIntyre would no doubt counter.

A– will begin to wonder how different both writers are, or rather, A– knows that they are different but he will wonder how. They both emphasise the virtue of a certain type of activity, which Macintyre terms 'practice', whereby 'goods' internal to that activity – such as a commitment to excellence – are valued more highly than 'goods of effectiveness', or 'external goods', which might be money or reputation. Or as Kathleen Kinkade, founder of the

most famous community based upon Skinner's principles has said (A– will have the photocopy in front of him):

'We have members who have the same intense dedication to their work that characterises happy professionals in the competitive outside world. Their involvement is with the work itself and with building the Community. The credits are beside the point, as the money would be beside the point if they were working for wages … The reinforcement comes from the finished product, the purr of the new engine, the neat row of baby trees – and from the appreciation of the other members of the community.'

A– will wonder where the 'goods' of his group activity lie, internally or externally. Maybe they will lie in a different place for him than they will for the rest of the group, maybe they will lie in different places for everyone involved and that will be somewhat the point. Perhaps there might be no planning for the future because each plan will only be based upon present knowledge, and an increased efficiency of our actions now will only result in our increased inflexibility in the future. In the midst of so much uncertainty, perhaps what will be needed is the preservation of as many different varieties of thought as possible, and this is what his old friend will have recognised, and what A– will be doing for the company all along. A– will collect his thoughts, and his papers, and go back down the stairs.

A– will put in his earphones, press the switch clipped to his lapel, and walk out onto the street.

le procés de pol pot

Coordonné par Liam Gillick et Philippe Parreno/Co-ordinated by Liam Gillick and Philippe Parreno.
Une série de propositions singulières de/Singular solutions proposed by the supervisors
Thomas Mulcaire, Pierre Huyghe, Rebecca Gordon Nesbitt, Douglas Gordon, Gabriel Kuri, Adrian Schiesser, Jeremy Millar,
Carsten Höller, Rirkrit Tiravanija, Ronald Jones, Pierre Joseph, Zeigam Azizov, Josephine Pryde, Terry Atkinson . . .

SPECULATION AND PLANNING
Liam Gillick and Anthony Spira

ANTHONY SPIRA The screens and platforms that form the DISCUSSION ISLAND and WHAT IF? SCENARIO series function on many different levels that propose a complex web of meaning. On one level, your works are intended to encourage thought and debate in the viewer, who then add and play with their meaning. This gesture appears to dilute the role of the author/artist and empower the viewer.

LIAM GILLICK The process you describe happens with all art to a certain extent, although a conscious play with it takes place here. When you place my artwork in relation to Minimalism or late modern formalism you can understand this process more clearly. The work doesn't share the same implication that art might be able to demonstrate an autonomy from other things in the world. My work doesn't have a fundamental 'truth to materials' and doesn't always do what materials do best. It often does what 'stuff' does least well, which is to be constructed and held in suspension. My work gently pokes at certain ideas about materiality because these physical objects are only one small part of a whole matrix of things that play with the way ideas are placed into hierarchies. There are also authorship implications in the exhibition related to a belief that the audience is multiple so you need to communicate to a number of audiences simultaneously through different routes. Marshall McLuhan wrote about ideas having different temperatures, but so do audiences and responses. People make constant visual judgements about their environment, which affect how they feel and how they behave, they are never passive viewers. On one hand it is very important that the work can be addressed and dealt with relatively quickly; but it's also important that it can have a delayed action that only snaps into focus later on. The work has a very immediate and sometimes beautiful potential that sucks people into other idea

arenas and it relies on the establishment of temporary relationships to sustain itself. The work is not a sequence of endpoints. I am trying to put forward fluctuating moments of connection. The viewer has to deal with the implications and potential of it.

AS So the 'significance' of your work is partially constructed by subsequent reactions to it and partially by parallel activities, like your writing, curating, talking and designing. Could you explain how your book DISCUSSION ISLAND/BIG CONFERENCE CENTRE, 1997, informs the DISCUSSION ISLAND and WHAT IF? SCENARIO series?

LG The first major texts were (several) film scripts all titled McNAMARA (1994), which were followed by the book ERASMUS IS LATE (1995). Both of these extended projects involved a condensed core of ideas that clearly emerged before the related artwork. Both texts addressed certain time games around how the near future and the recent past are constructed. As such I thought of them as parallel histories. Thinking about former US Secretary of Defence Robert McNamara led towards a more abstract discussion about planning and how people speculate. This was extended in ERASMUS IS LATE where I was trying to consider the legacy of free-thinking Georgian dynamics within the context of early industrial development and the missed opportunity for a republican revolution in Britain. When I started to work on the book DISCUSSION ISLAND/BIG CONFERENCE CENTRE, I wanted to look at the implications that these earlier socio-political moments had generated for our time and move into a discussion around the question 'who controls the near future in a post-utopian situation?'

Initially I failed to get anywhere and it occurred to me that it might be possible to use a quasi-formalist art discourse to kick-start the ideas and to generate spaces where people could suspend their usual speed of exchange and expression in a productive environment. The first step was an exhibition in Berlin in 1996 where I posited the idea framework of ERASMUS IS LATE against this emergent and rather nebulous concept. For the exhibition, I created an ERASMUS IS LATE room that contained a lot of content that had been developing over a number of years but in

the room next door I needed to indicate something new. By leaving the first platform – (THE WHAT IF? SCENARIO) SECOND STAGE DISCUSSION PLATFORM AND SURFACE DESIGNS, 1996 – alone in a room with nothing else and no other explanation, I was hoping to indicate that there was a revision of ideas and a visual shift about to take place. It functioned as an abstracted discussion space designating a move away from a text heavy, dinner party history play into attempts to look at the conditions around the planned middle ground. It echoed those socio-political spaces which are fought over within a neo-liberal consensus.

I believe in the intelligence of the multiple audiences for art and am vigilant and listening for the contexts generated by them. People started to make proposals in relation to this platform, and began to designate the provisional space. I didn't have to do much at that stage. People talked about the paradoxes inherent in what this platform thing appeared to be, what it implied and what it seemed to project. This was very liberating after having been bogged down in the ERASMUS IS LATE territory of parallel histories for a while. Suddenly there was access to a whole new set of audiences who were primarily retinal or visually literate in a different way and who were creating the conditions which would make it possible to evolve a new set of possibilities. I could set up propositions and carefully name them and design them so that people would start to feed me with ideas, setting up a series of conditions that could lead to

a book. This led to a sequence of titles that reflected the abstracted language of the socio-political middle ground that could form a back-drop for the content of the book and shift the concerns away from a collapsed form of J.G. Ballardism. This meant not so much focusing upon a clichéd sequence of destabilised characters, but constructing a more complex social view.

AS Sometimes you offer people clues or hints in your work, which might be misleading or confusing. The wooden structure in this exhibition could even be described as a mock IKEA self-assembly kit into which the screens and platforms are slotted. How does this extensive use of exposed pine planking contribute to your work?

LG I was thinking about utopian periods where display in general was rethought, although if you study photos of THE ARMORY SHOW (1912), for example, you will realise that it was not a total break from the past. It felt like a salon style hang with echoes of its recent past. Within a relatively short time, notions of display accelerated to match the art. Yet there was a very peculiar moment in modernism where complicated exhibition displays were visibly made out of sheet angle and tube. Before people started manufacturing specialised display systems, they were still using funda-mental materials. These earlier display techniques complicate and problematise the idea of the aesthetic of modernism. My concern was how to prevent this exhibition from being an excessively connoisseurly experience where the work would be read as a sequence of borrowed 'pieces' all taken out of context. While there is no direct reference to IKEA the designed structure exists in order to present a new way of re-contextualising the work and problematising its relation to the familiar dynamics of a public gallery space. The ideas I

have been playing with produce more than straightforward objects for consideration, but, within a gallery space, art tends to be the focus. It is important to find a way to get across the potential of the combined ideas and screw up the hierarchy that exists between things which are more immediately recognisable as art and all the rest of the structural elements in the exhibition. This is not in order to make some point about modernism but to give the less formalised ideas a chance to leak through.

AS The installation comprises a simple wooden structure. Is it a parody, as in LITERALLY NO PLACE (2002) where the visitors to the commune 'feel the ball of each foot pushing the earth down' as they walk? Was there a conscious play between the clinical materials that you are more frequently associated with and nostalgia for an elemental sensibility?

LG The construction of the work is relatively simple, although it does involve materials familiar from the world of renovation and presentation. When you buy a tin of tuna and it feels like there is less and less fish in the can, maybe it's because the packaging is getting bigger. These things don't seem very profound but they actually affect us and prick our conscience. They're the visible end of a dynamic that exists in the developed world which also affects who decides whether you have a job or not, how you can function, how you can move through the city and who controls public spaces. All these questions are bound up in ideas around the semiotics of presentation and corporations are vigilant for the moment when the fish has to make a comeback. I have a specific allegiance to certain ideologies that are against that search for how you can sell the least thing for the most money to the largest number of people. These ideological negotiations are always present in my work. To a certain extent the presence of the wooden structure does function to ground the work in a constructed relational context that functions as a sign for the complex circumstances that surrounded the creation of the work in the first place.

AS Given the quantity of wood in the exhibition, the title of the show, THE WOOD WAY is particularly apt. As you have also explained, it comes from the common German

NEUTRAL RISK +1
NEUTRAL RISK +0.9
NEUTRAL RISK +0.8
NEUTRAL RISK +0.7
NEUTRAL RISK +0.6
NEUTRAL RISK +0.5
NEUTRAL RISK +0.4
NEUTRAL RISK +0.3
NEUTRAL RISK +0.2
NEUTRAL RISK +0.1
NEUTRAL RISK
NEUTRAL RISK −0.1
NEUTRAL RISK −0.2
NEUTRAL RISK −0.3
NEUTRAL RISK −0.4
NEUTRAL RISK −0.5
NEUTRAL RISK −0.6
NEUTRAL RISK −0.7
NEUTRAL RISK −0.8
NEUTRAL RISK −0.9
NEUTRAL RISK −1

MIND MAP, 2002
Allianz Risk Transfer, Glamour Engineering, Zurich

expression 'Holzweg', which means deliberately or inadvertently taking the wrong route and ending up 'in the woods'. It also echoes the title of a book by Heidegger.

LG The expression describes my attitude to a certain extent although I have no great interest in Heidegger or his value systems. The exhibition could be like a walk in the woods, which is crucial because it reminds people that my work is not always a logically researched track of ideas. There are so many moments where things fall apart, where they don't go anywhere, where they reach a dead end. It's an acknowl-edgement of all the time that I have spent working outside of the UK involved in other discussions and value systems. But there's also a suburban reference in there somewhere because wherever there's an Acacia Avenue there's probably a Wood Way. My sense of distraction and delusion is certainly influenced by a suburban upbringing, and there's a nod to this in the title of the show.

AS The screens and platforms clearly echo readymade architectural units that you find both in council estates and corporate architecture. They seem to demonstrate one of your fundamental concerns – the evolution of modernist architecture through planning (a social phenomenon) to speculation (a capitalist venture).

In some ways the exhibition functions as a small model of urban design which both demonstrates and investigates these notions of planning and speculation. For example, the

layout offers a route that is planned to maximise the visitor experience. Equally, the installation involves speculation, in the anticipated increase in value of the work both conceptually and commercially…

LG You could argue that one of the great battles of the twentieth century was between speculation and planning and you could pretty much say that speculation won. Most major utopian public housing projects were over by the end of the 1960s. These were really important and arguably flourished within a more constructive and progressive set of ideologies. But the Modern Project didn't stop with the collapse of Ronan Point and the fact that estates were badly maintained and managed; instead it continued in the corporate world. People who had been working on very interesting utopian housing projects shifted into the corporate sphere and did good modern work for corporate interests instead. I am very interested in this question of speculation and planning and all the contradictions and grey areas in-between. We are now in a situation where the relation between the two is super complex, and folds over into itself to produce new layers of contradiction that are (normally) signified through traces left on the urban landscape. I have lived through that moment and into the time of renovation, where the battle to reclaim space is always accompanied by a new foyer.

The show could be read as a microcosm of the conflict between these value systems. You have clear souvenirs or objects (artworks) that are gathered primarily from the developed world and inserted into the new planned gallery structure, which becomes a semi-public space holding evidence of semi-private space. It may well be that a feeling of utility combined with a speculative echo will promote questions about the relative value of ideas and objects. I am

genuinely curious about how it is going to come across and whether those things that you have described will actually be readable. I'm not sure.

AS Another reading of the exhibition might be more sculptural in the sense that this labyrinthine construction of penetrable spaces leads to 'hermetically' sealed cubes so that there is an interplay between interior space and exterior surface or skin. I also understand the exhibition to be about perception. Apart from the platforms making visitors look upwards, the surfaces of your work vary from opacity to transparency and reflection with varying degrees of visibility (depending on your angle to the wooden slats in particular).

Looking at the exhibition designs, I was immediately reminded of French novelist Alain Robbe-Grillet's writing and particularly LA JALOUSIE, 1957 which is the same word in French for jealousy and Venetian blind. In short, Robbe-Grillet explored how understanding is constructed by a combination of 'objective' and 'subjective' realities in the sense that your imagination fills in the gaps as you look through the slats in a blind. I feel that the exhibition picks up on these experiments and tackles notions of perception and potential engagement in a different way.

LG One of Robbe-Grillet's great achievements is that his writing can make you go rigid while it simultaneously reveals controlled passion. While I wasn't thinking particularly about that book, I'm certainly aware of the psychological spaces that he often describes. While I was working at Le Consortium in Dijon I fell into a state of delusion and distraction which I escaped from by slowly renovating the doors of the art centre. You could interpret this as a literalising of Robbe-Grillet's technique. While I was supposed to be doing my exhibition, I spent a lot of time with a razor blade scratching paint off the glass doors and cleaning the fittings, renovating the entrance and making it better. People coming to the exhibition were not aware of it but their initial experience was affected. I had shifted the initial visual exchange of ideas by focusing so carefully on this one overlooked detail.

If it works well, the combination of the slats and semi-

obstructed wall systems won't be a clunky and metaphorical 'window through to a set of ideas' but will relate more to questions of detailing. Not in a high modernist sense of Wittgenstein designing door handles, but more in line with the idea of scratching paint off glass or checking something as you wander past. I hope it will really reactivate questions to do with how you frame your snatched look at the world. The work is an actualisation of these ideas.

AS Why are you so playful with the act of seeing if there is no metaphorical significance? Are you simply playing with seeing as a pleasurable act?

LG There is a functional aspect to the work. Over the past fifteen years I have talked to a lot of artists connected to conceptual art and reviewed ideas around changing the relationship between the viewer and the object and the potential of art. Some of these artists remain central to my thinking but I also met those who claimed to have avoided the question of aesthetics. I'm happy to go along with the game of suppressing aesthetics in favour of trying to communicate certain ideas but I don't think it's possible. There is an absolute scepticism and enthusiasm in my work that involves visual kleptomania and visual pleasure alongside a crucial understanding that I am not proposing metaphorical relationships. I am grappling with real object and idea relationships that affect personal politics; how to negotiate a city; who controls the near future; how can we understand the processes of renovation and so on. None of these

issues are illustrated in the work, but the work creates thought spaces which highlight both the concepts themselves and proposes an alternative view.

AS There is this constantly flickering role for the visitor between being a spectator or a participant. You are offering them both something to look at and something that they can contribute to which in some way reflects your role of planning and executing.

LG The thought space that I am offering is flat and works as a matrix of parallel ideas. Because I work with precise diagrams, everything is always super-planned. About four years ago I started planning to a much greater extent. This was an acknowledgement that while the ideas I was playing with were extremely malleable they also had a brittle property. Excessive improvisation at the time of an exhibition only accentuated the brittleness. When dealing with the issues generated by the production of DISCUSSION ISLAND/BIG CONFERENCE CENTRE it became important to formalise the relationship between planning and execution, otherwise the ideas that I was reaching for would always be squashed by an excess of art values.

AS Rather than committing authorial suicide as we discussed earlier, you multiply your role so that your authorial power, rather than being relinquished to the viewer, is actually hidden under a multiplicity of guises. Does the glitter that you use in your work appropriate ideas from Felix Gonzalez-Torres and replicate the aftermath of a party, for example?

LG It is definitely not about taking on a persona but it is about acknowledging my sources. Felix Gonzalez-Torres is very important because he passed through the classic, didactic discourse that surrounded issues of identity

and sexuality and created new forms of beauty that were rooted in deep and serious ideas. I learnt something from the way his work plays with form and the way that you can loosen up to a certain extent. That's very crucial and the glitter is absolutely an acknowledgement of this influence. The fact that the glitter in my work is always used in combination with a spirit like vodka to clean the floor changes things through the simplicity and short-termism of the act. It also acknowledges my work ethic and my regard for pragmatism and constructed ideas. My work is not a question of just sending an instruction to a factory. Jorge Pardo, another Cuban-American artist also complicated my relationship with the idea of the signifier and the signified. In other words, he showed where you might find moments of serious play within art propositions that move things away from the simple logic of idea, conception, realisation, display towards a more muddled discussion between all of these issues.

AS The photograph of Dr Robert Buttimore that was taken on your trip to Brittany to explore ancient megaliths several years ago is a totally uncharacteristic work. You have mentioned him before as a mentor figure and this trip obviously had a lot of personal significance…

LG That photograph has a heavy-duty symbolic significance. If you know someone when you're very young, who is not connected to you through family and who is not your teacher, you can end up with an ease of relationship that is not over determined. What he does in relation to the exhibition is indicate that there are presences in the work that are not always floating on the surface. It also shows that there are works that don't get discussed and discursive moments that don't apparently lead anywhere. In the exhibition, that image functions as a corrective device. It has a very functional role in case anyone thinks that the exhibition is depersonalised or only about certain questions of urbanism.

AS THE WOOD WAY has gradually developed in my mind as an interchangeable version of your latest book LITERALLY NO PLACE. It was more or less written at the same time as some of the work in the exhibition was constructed and the book will come out on the same

FUCKTHENEWAUSTRIANGOVERNMENT, 2000
Schipper & Krome, Berlin

front of card NEUE HELVTICA BOLD

childrenofnineortenaredragged
fromtheirsqualidbedsattwothre
eorfouroclockinthemorningand
compelledtoworkforabaresubsi
stenceuntiltenelevenortwelveat
nighttheirlimbswearingawayth
eirframesdwindlingtheirfacesw
hiteningandtheirhumanityabsol
utelysinkingintoastoneliketorp
orutterlyhorribletocontemplate

back of card NEUE HELVETICA BOLD

night as the exhibition opening, so at the very least their production will merge. I understand both the book and the exhibition to present a kind of utopia where visitors (hopefully) develop their mutual interests and contribute to discussions on planning, speculation and ethics, etc.

LG The phrase 'literally no place' is one way of understanding the word utopia. Once I had stolen the title I became more interested in something more concrete and functional than making general points about utopia, which is why the subtitle to the book is COMMUNES, BARS AND GREENROOMS. To a certain extent, I'm interested in the idea of 'functional utopia', which could be a negative thing a little like being a 'functioning alcoholic'. It is an acknowledgement that while there's clearly a problem, there is no reason to stop thinking about how things might be better. What you end up with is not so much a meditation on utopia but an attempt to play with or expose certain kinds of functional utopias. It's an echo of utopia, where brief glimpses are heightened. The bar, the commune and the greenroom are places where the pragmatising pressure to hold back ideas is suspended for as long as possible. You could argue that the exhibition is a demonstration of a compromised diagram of a functional utopia. You could suggest that the combination of the factors involved, like the adjustments to the café and lecture theatre which leave the original elements all in place, acknowledge the potential of existing spaces and tries to heighten them without resorting to the

corrupted language of renovation and short term control. While this will inevitably lead to collapses of understanding and realisation, it might also demonstrate the contradictions inher -ent in any contemporary attempts to resolve the paradoxes of our neo-liberal condition.

LINE	————	COLOR	————	STRUCTURE

———————— REALITY

LITERAL	——	METAPHORICAL	——	MATERIAL

IS GILLICK BEGGING THE QUESTION?

FORM CAN ONLY FOLLOW FUNCTION IF FUNCTION IS PRE-ORDAINED

IF THERE IS AN INHERENT FORM FULLY EQUIPPED WITH INHERENT MEANING

& POWER STEERING THE DRIVE TOWARDS A PRE-DETERMINED END (THE END)

THE ONLY JUSTIFICATION FOR THE EXISTENCE OF ART IS TOWARDS

A NOT DETERMINED END (AN END)

CAN GILLICK

WITH A WAVE OF HIS HAND REMOVE THE GANG

MEMBER FROM THE GANG JACKET (COLORS)

WITH A PUFF OF SMOKE REMOVE THE PRODUCT FROM THE LOGO...

PERHAPS

IF IN DESIGN LINE IS IN FACT MEANING

IF IN ART LINE IS A MEANS TO AN END

IF IN DESIGN COLOR IS IN FACT MEANING

IF IN ART COLOR IS A MEANS TO AN END

IF IN DESIGN STRUCTURE IS IN FACT MEANING

IF IN ART STRUCTURE IS A MEANS TO AN END

THE QUESTION THEN BECOMES TOWARD WHAT END

ERGO: ART

IS IT IDEALISTIC TO THINK THAT WHOMSOEVER ENTERS INTO/WITHIN A

GILLICK MISE-EN-SCENE CAN SEE THE WORLD NOT AS A PARADIGM OF

WHATSOEVER BUT DEAL WITH THE COMPONENTS AS THE THINGS THEMSELVES

& AS A MEANS TO AN END

PERHAPS

(SCHWITTERS SEEMED TO DO IT)

LAWRENCE WEINER FEB. 2002 NYC

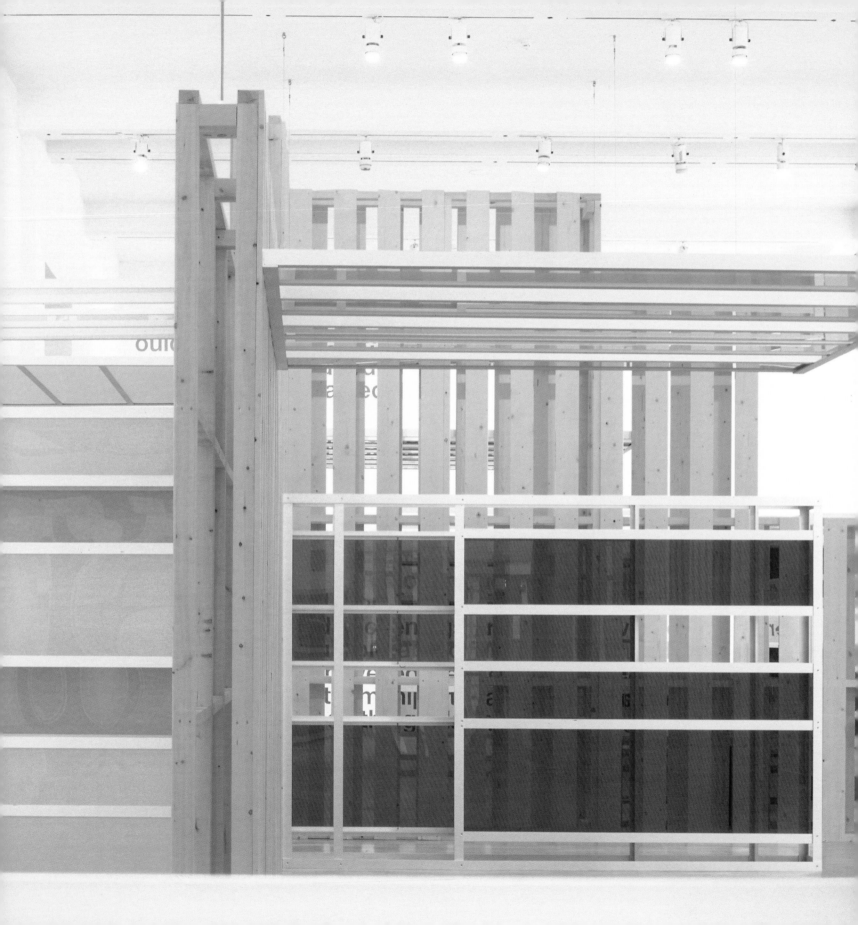

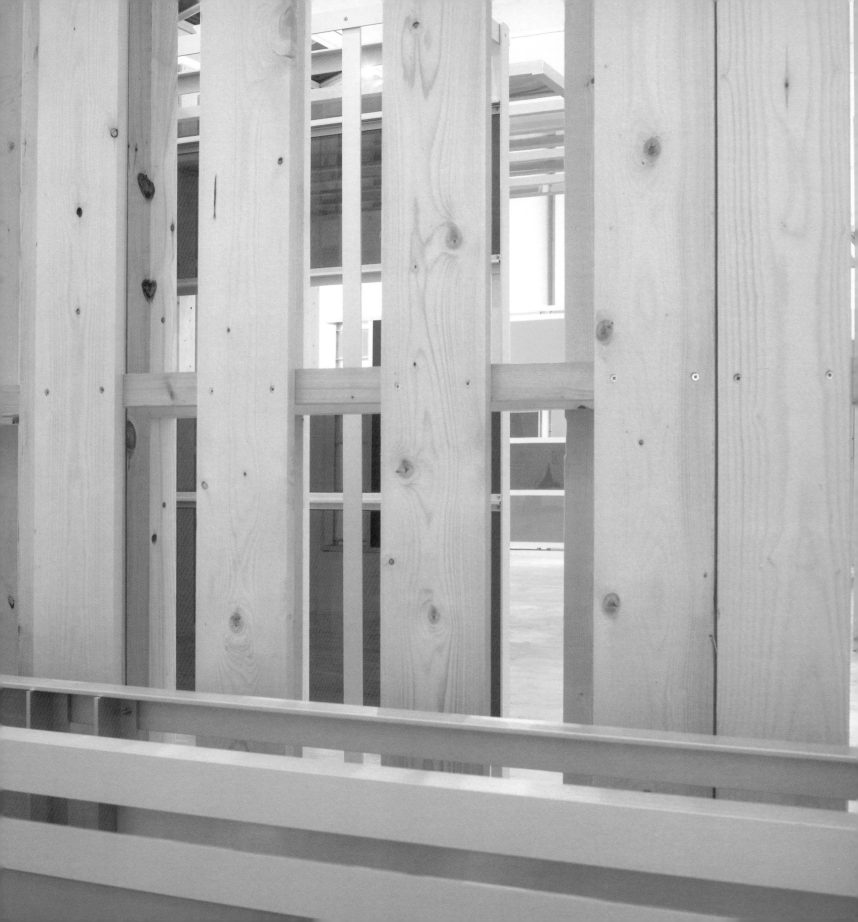

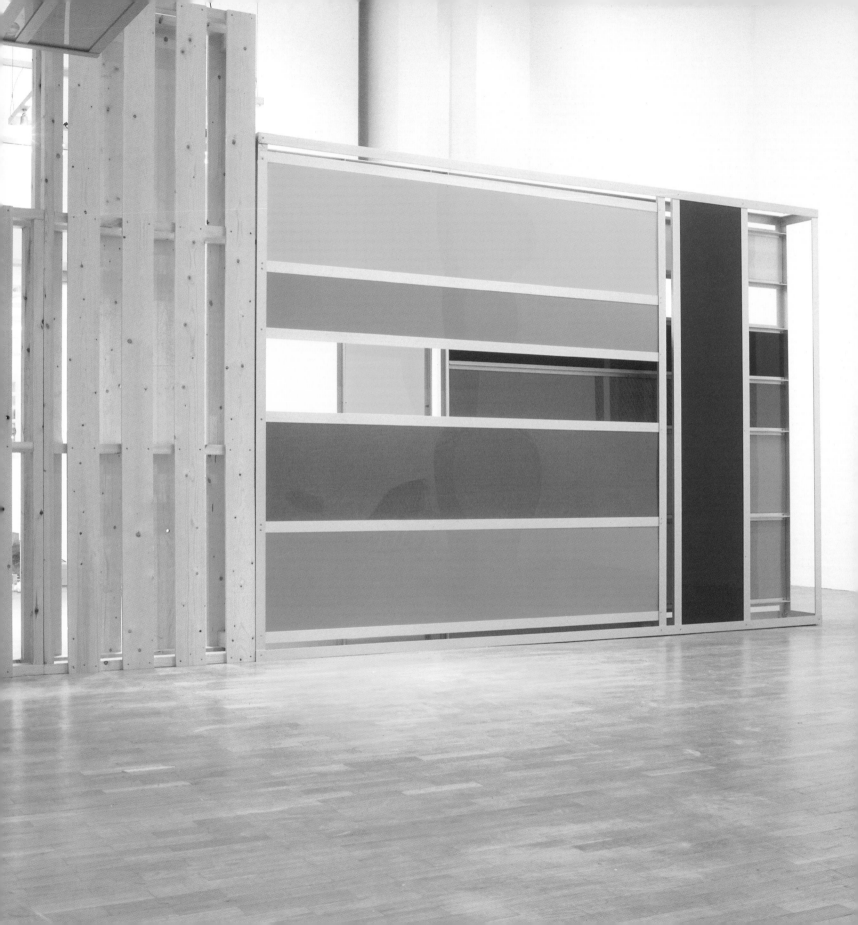

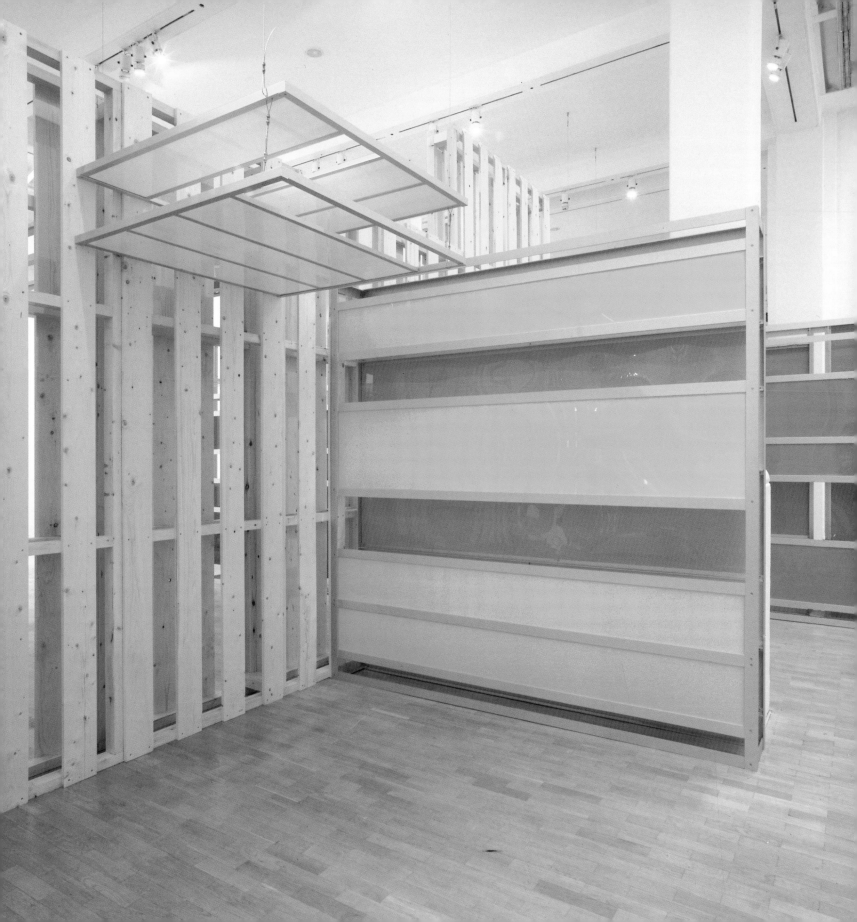

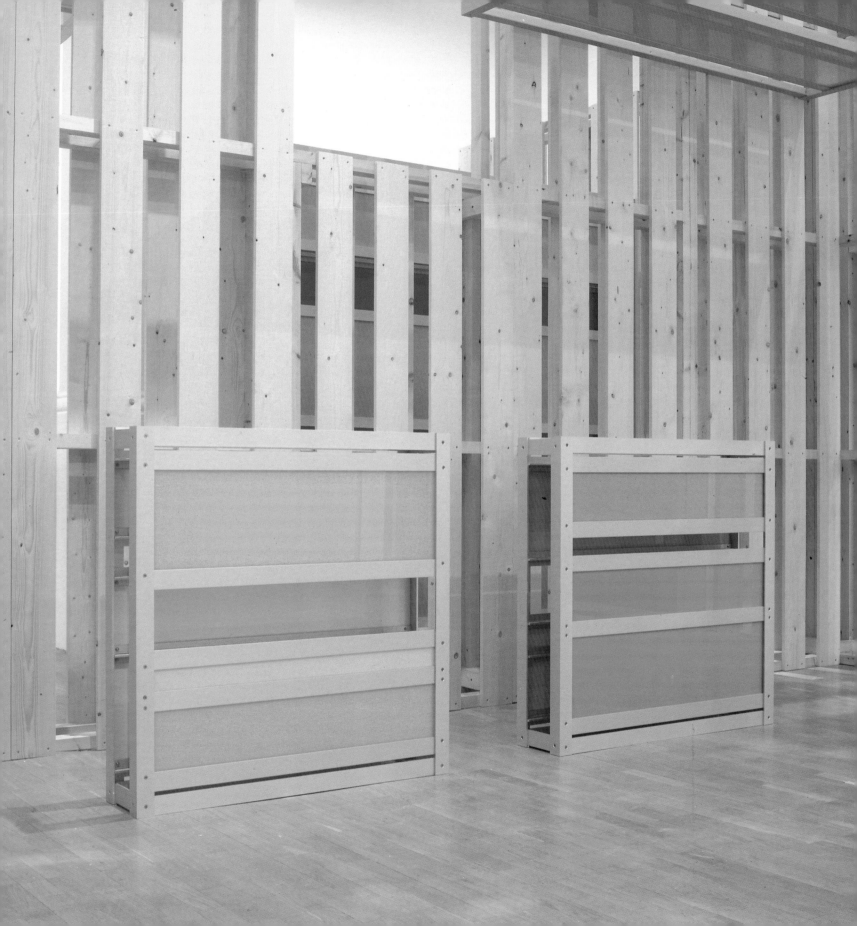

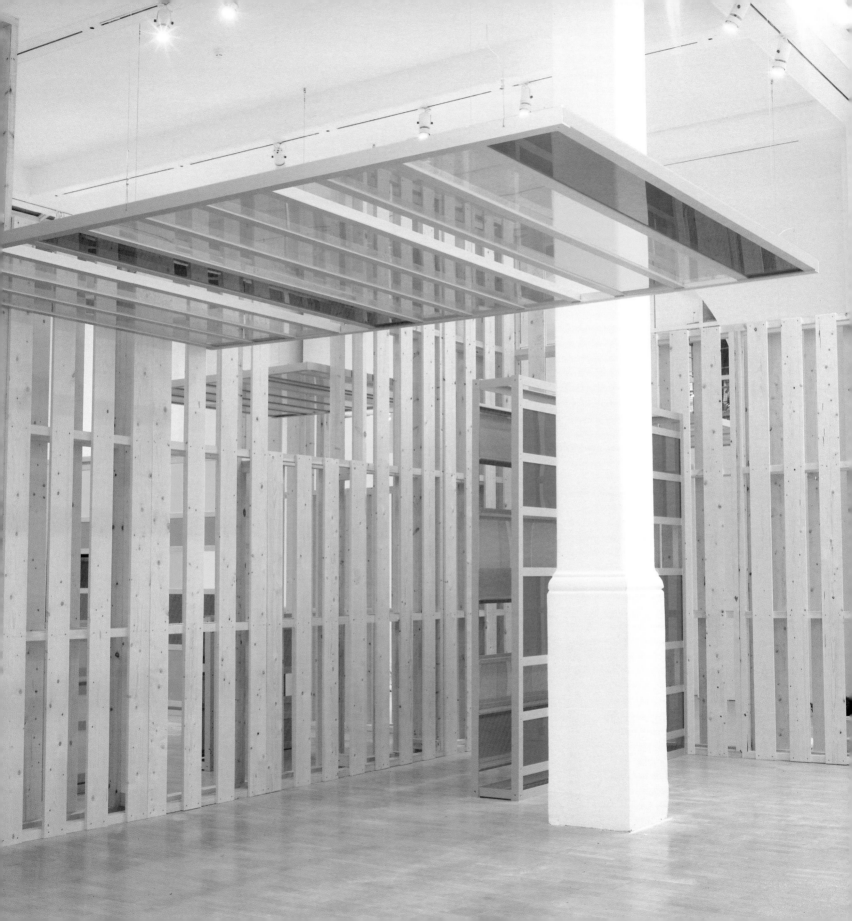

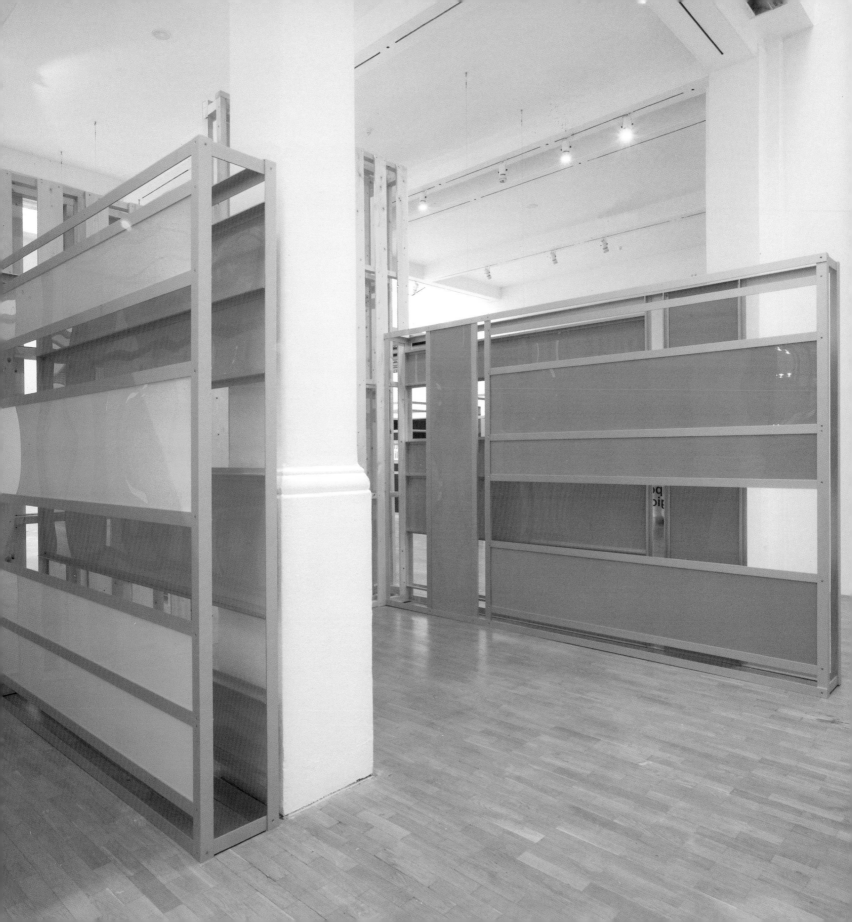

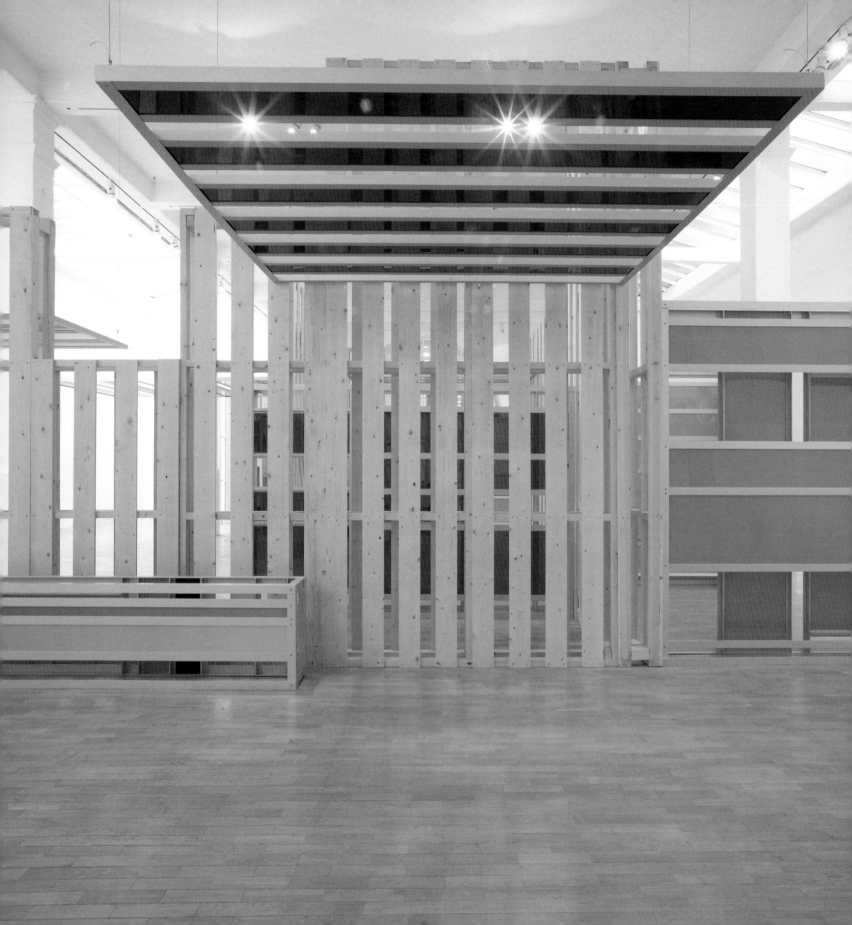

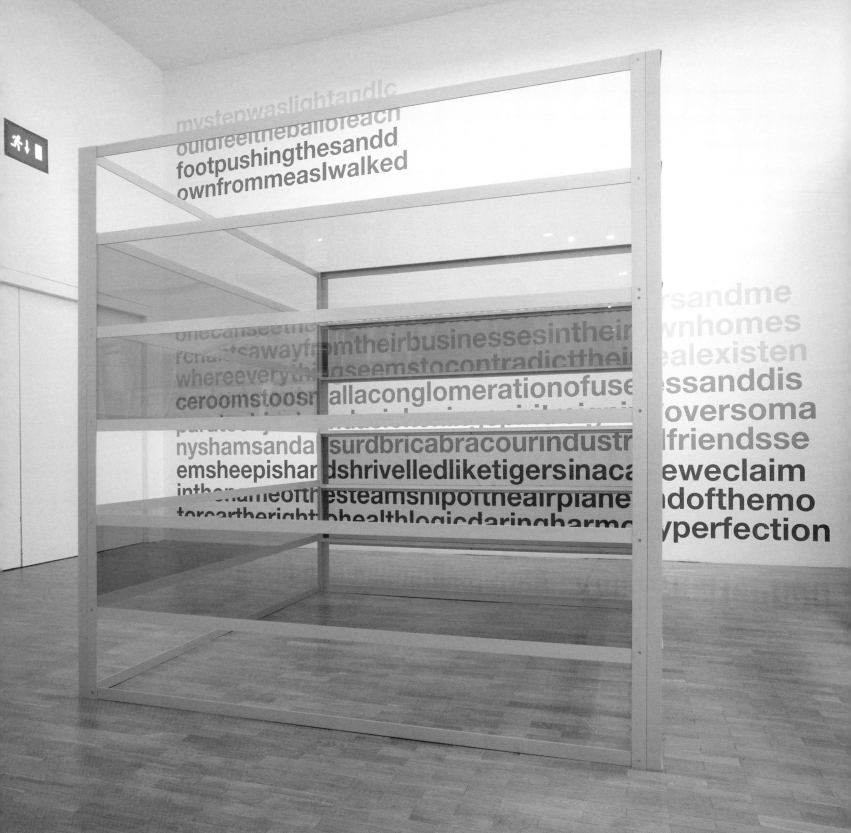

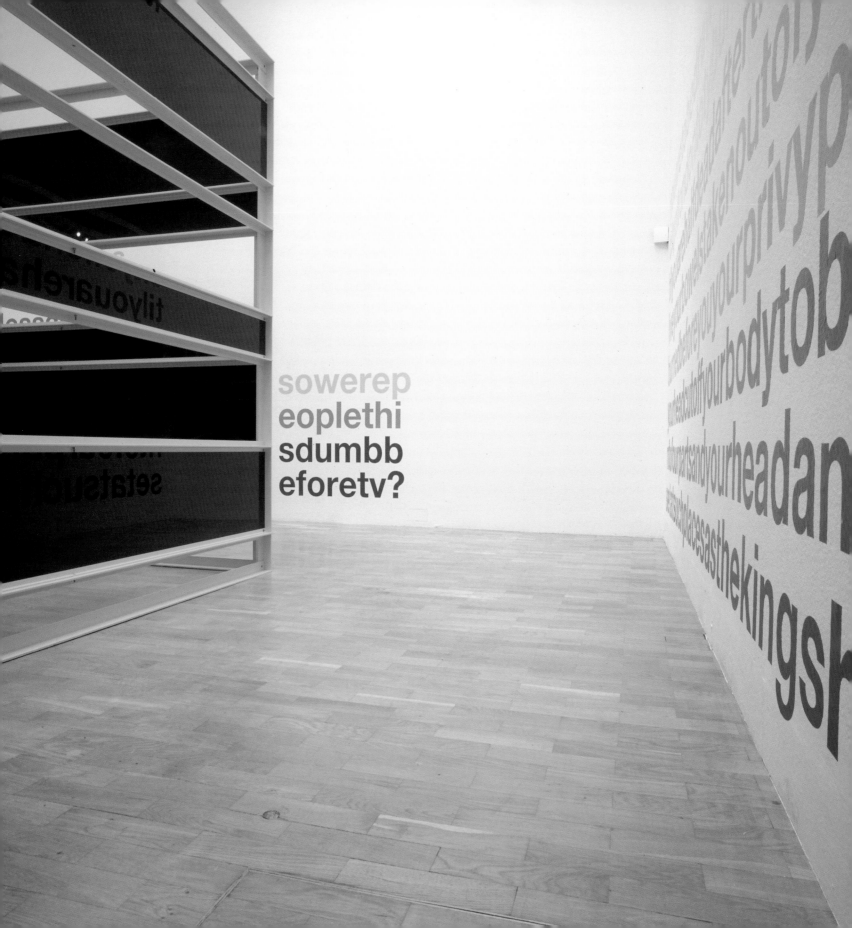

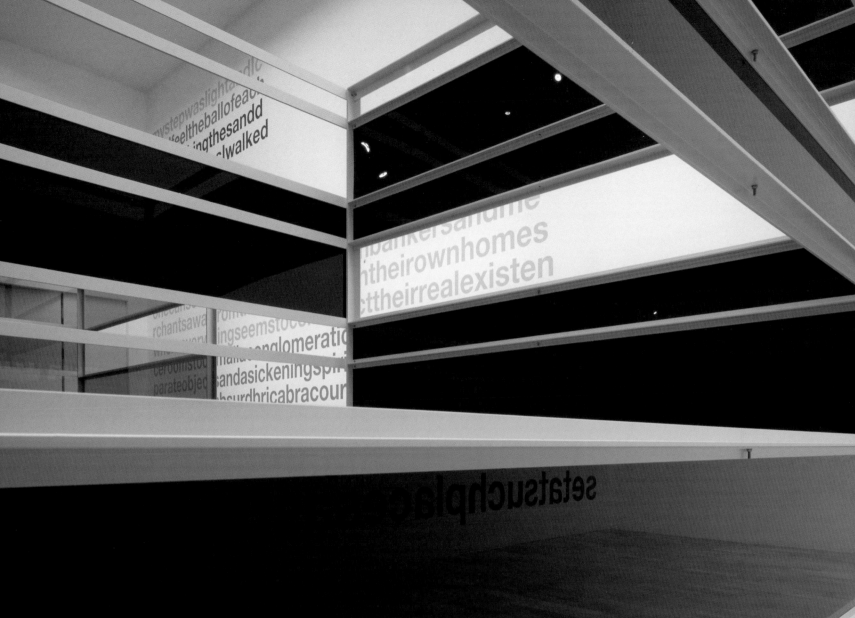

LIST OF WORKS

CAFÉ
ADJUSTMENT FILTER, 2002
various materials. In collaboration with Nick and Alison Digance.

LECTURE THEATRE
PROTOTYPE CONFERENCE ROOM WITH JOKE BY MATTHEW MODINE (ARRANGED BY MARKUS WEISBECK), 1999 (JOKE LOCATED IN CAFE) various materials, coloured cloth,
Courtesy the artist

GALLERY
DR ROBERT BUTTIMORE, 1997
colour photograph, frame, 40 × 50 cm, Edition 2/5
Courtesy the artist and Paul Mittleman, Los Angeles

DISCUSSION ISLAND: ARRIVAL RIG, 1997
anodised aluminium, 10 lamp units, 10 75w spots, 5 × 120 × 120 cm
Jack and Nell Wendler, London

DISCUSSION ISLAND DIALOGUE PLATFORM, 1997
anodised aluminium, white opaque Plexiglas, 2 elements, each 5 × 120 × 120 cm
Private collection, Berlin

DISCUSSION ISLAND MODERATION PLATFORM, 1997
anodised aluminium, black opaque Plexiglas, 5 × 240 × 240 cm
Courtesy Schipper & Krome, Berlin

DOCUMENTARY REALISATION ZONES #1 TO #3 (part), 1997
brass handle, hinges and lock
Collection Le Consortium, Dijon

POST DISCUSSION LIMITATION PLATFORM, 1998
anodised aluminium, red, yellow, light blue, orange transparent Plexiglas, 5 × 240 × 240 cm
Private collection

SO WERE PEOPLE THIS DUMB BEFORE TELEVISION, 1998
vinyl wall text, variable dimensions
Courtesy Schipper & Krome

REGULATION SCREEN, 1999
anodised aluminium, red transparent Plexiglas, 200 × 300 × 60 cm
Collection Marc & Josée Gensollen, Marseille

DELAY SCREEN, 1999
anodised aluminium, yellow, orange, red, blue opaque Plexiglas, 240 × 360 × 30 cm
Collection Brian McMahon, New York & courtesy Casey Kaplan, New York

CONSULTATION SCREEN, 1999
anodised aluminium, light blue, yellow, orange, red opaque Plexiglas, 60 × 360 × 40 cm,
Courtesy Casey Kaplan, New York

RENOVATION PLATFORM, 2000
anodised aluminium, grey opaque Plexiglas, 5 × 200 × 200 cm
Private collection, Milan

PROJECTED LOCATION PLATFORMS #1 TO #6 INCLUSIVE, 2000
anodised aluminium, grey opaque Plexiglas, each element 3 × 120 × 120 cm
FRAC, Poitou-Charentes

DEVELOPMENT, 2000
vinyl wall text, variable dimensions
Courtesy the artist

LOBBY SIGNAGE, 2000
vinyl wall text, variable dimensions
Courtesy Michael Trier, Cologne

STABLE BLOCK #1, 2001
powder coated ivory aluminium, brown opaque Plexiglas, 240 × 240 × 240 cm
Courtesy Corvi-Mora, London

CONVEYAUNCE, 2001
anodised aluminium, yellow and ivory opaque Plexiglas, 100 × 100 × 20 cm
Private collection

OBEDIENS, 2001
anodised aluminium, grey and orange opaque Plexiglas, 100 × 100 × 20 cm
Galerie Thaddaeus Ropac, Salzburg-Paris

COUSIN/LITERALLY NO PLACE, 2001
anodised aluminium, blue and grey opaque Plexiglas, 240 × 240 × 30 cm
Collection F. Meana, Madrid

LOCALISED DISCUSSION SCREEN, 2001
anodised aluminium, orange opaque Plexiglas, 124 × 360 × 30 cm
Private collection, Korea & courtesy Casey Kaplan, New York

FILTRATION, 2001
anodised aluminium, light blue, orange transparent Plexiglas, 240 × 250 × 240 cm
Courtesy Galerie Hauser & Wirth & Presenhuber, Zurich

WALDISH SCREEN #1, 2001
anodised aluminium, yellow, grey opaque Plexiglas, 240 × 240 × 30 cm
Courtesy Galerie Hauser & Wirth & Presenhuber, Zurich

DOUBLEBACK PLATFORM, 2001
anodised aluminium, yellow, orange opaque Plexiglas, 250 × 120 × 120 cm
Purchased by the Contemporary Art Society, 2001

RESOLUTION PLATFORM, 2001
anodised aluminium, red, yellow, orange, light blue transparent Plexiglas, 5 × 200 × 200 cm
Private collection, Geneva

MY STEP WAS LIGHT, 2001
vinyl wall text, variable dimensions
Courtesy Galerie Hauser & Wirth & Presenhuber, Zurich

ISEEYEAREDETERMINEDTOCONDEMNEME, 2001
vinyl wall text, variable dimensions
Courtesy Ringier Collection, Zurich

EIN RÜCKBLICK AUS DEM JAHRE 2000 AUF 1887, 2002
anodised aluminium, Plexiglas, 5 × 240 × 360 cm
Courtesy Corvi-Mora, London

SOME WORKS, PROJECTS
AND GRAPHICS 1998 – 2002

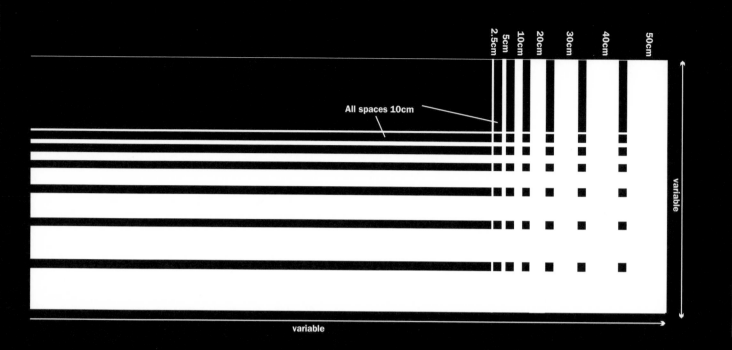

All spaces 10cm

2.5cm 5cm 10cm 20cm 30cm 40cm 50cm

variable

variable

N FILTER/RECENT PAST AND NEAR FUTURE
)00
ooden partition

rtition to be
d on site from
ved and glued

vo identical units

projection
of wall partition

PROJECTED LOCATION PLATFORMS #1 TO #6
FRAC Poitou Charantes

I grey opaque Plexiglas

30cm

20cm

20cm

10cm

30cm

20cm

30cm

LITERALLY NO SYSTEM #1, 2000
Private collection, Paris

**MDF Sheeting (2,5cm thick)
cloth, coloured cord**

40cm

20cm

40cm

20cm

20cm

200cm

200cm

20cm

umneouhliberalismkindofyouknowpromotessortofcommercialisationuhitstrengthensumtheyouknowcon

Each letter approximately 20cm or 25cm high

dofyouknow
ercialisationuhit
knowcommercial

jumtheyouknow
onomyorwhatever

ALLIANZ

possible location for
projection screen

X

X

HELVICAL BOLD
ie windows or hanging
windows
he Allianz building.
upside down

idding can be wrapped
und the new wooden beams
ing coloured cloth

:m

original beams sh
extra beams in yel

...whileuhweakeningumtheyouknowth
ekindofpowerofautonomyorwhatever

Projected light/sun/moon

background dark blue

5 metres

Wittes
learning
and studie

Walther Koenig Books Ltd.
at the Serpentine Gallery

Liam Gillick
APPLIED FOYER DESIGN (trad. Celtic circa. 300A.D. arranged by Liam Gillick)
2000

☐ deep orange/red

96"

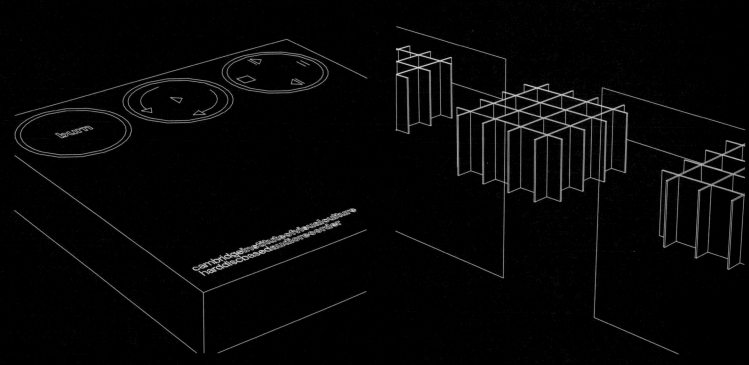

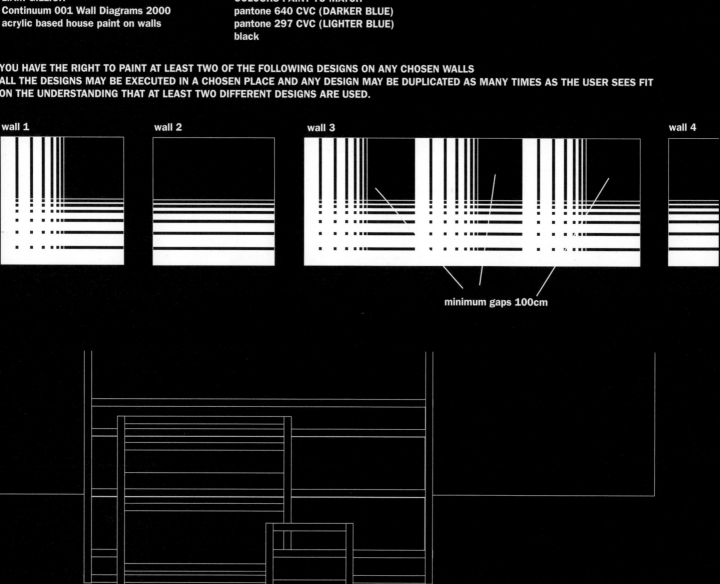

Continuum 001 Wall Diagrams 2000
acrylic based house paint on walls

COLOURS PAINT TO MATCH
pantone 640 CVC (DARKER BLUE)
pantone 297 CVC (LIGHTER BLUE)
black

YOU HAVE THE RIGHT TO PAINT AT LEAST TWO OF THE FOLLOWING DESIGNS ON ANY CHOSEN WALLS
ALL THE DESIGNS MAY BE EXECUTED IN A CHOSEN PLACE AND ANY DESIGN MAY BE DUPLICATED AS MANY TIMES AS THE USER SEES FIT
ON THE UNDERSTANDING THAT AT LEAST TWO DIFFERENT DESIGNS ARE USED.

wall 1

wall 2

wall 3

wall 4

minimum gaps 100cm

WALDENICITY, 2001
Corvi-Mora, London

120cm

120cm

120cm

DOUBLED RESISTANCE PLATFORM #2, 2001
Atle Gerhardsen, Berlin

20cm 40cm 20cm 20cm 20cm

empty empty

200cm

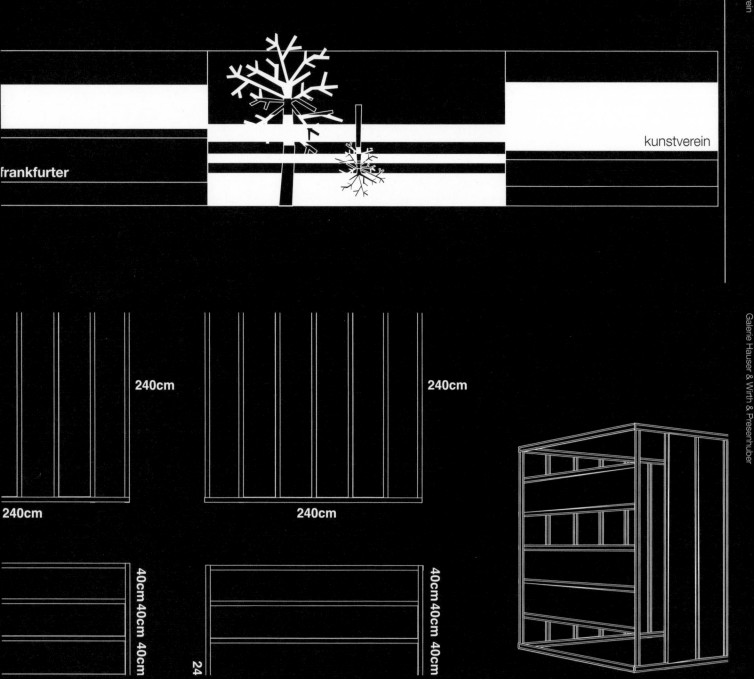

frankfurter

kunstverein

240cm

240cm

240cm

240cm

40cm 40cm 40cm

40cm 40cm 40cm

24

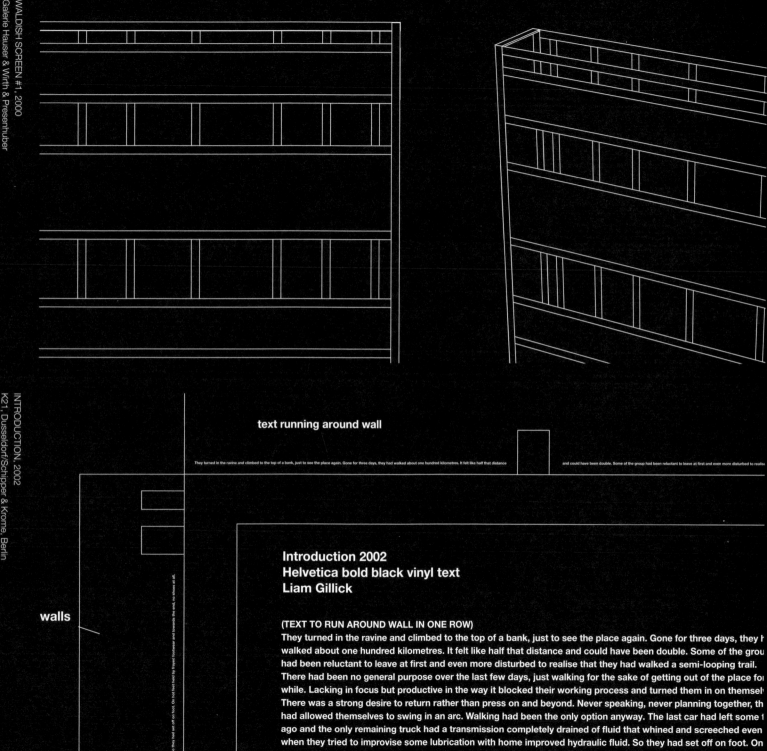

text running around wall

They turned in the ravine and climbed to the top of a bank, just to see the place again. Gone for three days, they had walked about one hundred kilometres. It felt like half that distance and could have been double. Some of the group had been reluctant to leave at first and even more disturbed to realis

walls

Introduction 2002
Helvetica bold black vinyl text
Liam Gillick

(TEXT TO RUN AROUND WALL IN ONE ROW)
They turned in the ravine and climbed to the top of a bank, just to see the place again. Gone for three days, they h
walked about one hundred kilometres. It felt like half that distance and could have been double. Some of the grou
had been reluctant to leave at first and even more disturbed to realise that they had walked a semi-looping trail.
There had been no general purpose over the last few days, just walking for the sake of getting out of the place fo
while. Lacking in focus but productive in the way it blocked their working process and turned them in on themsel
There was a strong desire to return rather than press on and beyond. Never speaking, never planning together, th
had allowed themselves to swing in an arc. Walking had been the only option anyway. The last car had left some t
ago and the only remaining truck had a transmission completely drained of fluid that whined and screeched even
when they tried to improvise some lubrication with home improved hydraulic fluid. So they had set off on foot. On

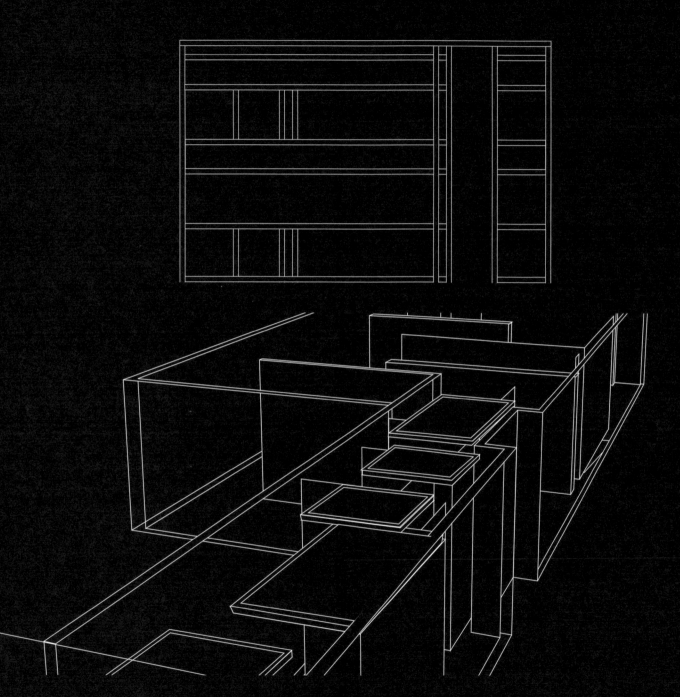

52.
The Wood Way
Liam Gillick

EVERY DRINK AVAILABLE IN THE BAR
Liam Gillick 2001
JAVIER LOPEZ
matt vinyl text on wall
GREY
LIGHT BLUE

transcription of text

someone/has/put/together/a/
book/with/photographs/of/every/
drink/available/in/the/bar/they/
haven't/cheated/even/though/
they/could/have/used/the/same
photo/for/both/gin/and/tonic
and/vodka/and/tonic

15cm

someonehasputtogetherab
ookwithphotographsofever
ydrinkavailableinthebarthe
yhaven'tcheatedeventhoug
htheycouldhaveusedthesa
mephotoforbothginandtoni
candvodkaandtonic

someonehasputtogetherab
ookwithphotographsofever
ydrinkavailableinthebarthe
yhaven'tcheatedeventhoug
htheycouldhaveusedthesa
mephotoforbothginandtoni
candvodkaandtonic

of the most important people involved in the development of computer games.
together to make one big compound word.

koy	okoigumpeialexeypajitn	oviwatanitorusuzukiyu	miyamotoshigerukutar	agikenendomasanobui	shiharatsunekazuxnish	ikadotomohirc

- each s
- metalli

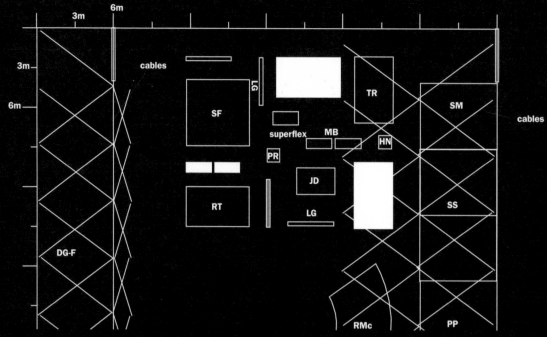

**What If/Tänk Om
ground plan
Liam Gillick
2000**

GROUND PLAN FOR WHAT IF/TÄNK OM, 2000
Moderna Museet, Stockholm

PROJECTION VIEW FOR WHAT IF/TÄNK OM, 2000
Moderna Museet, Stockholm

54.
The Wood Way
Liam Gillick

LITERALLY, 2002
Wall diagram and hanging structure for Museum of Modern Art, New York

colours of wall design and hanging structure to
match Pantone colours:
1345 cvc
1355 cvc
1365 cvc
1375 cvc
1385 cvc
1395 cvc
1405 cvc

elevation of hanging structure

Taciturnitie and Silence (Taciturnitie)
edition plan for Parkett/2001
ideal colours and number of elements 2 (either constructed from anodized/coated aluminium or plastic sheet?)

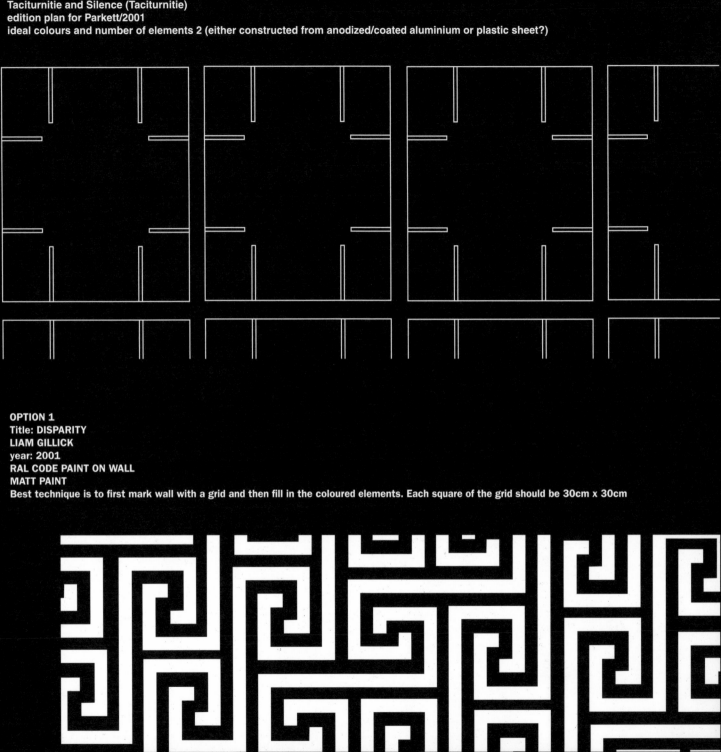

OPTION 1
Title: DISPARITY
LIAM GILLICK
year: 2001
RAL CODE PAINT ON WALL
MATT PAINT
Best technique is to first mark wall with a grid and then fill in the coloured elements. Each square of the grid should be 30cm x 30cm

100cm

100cm

20cm

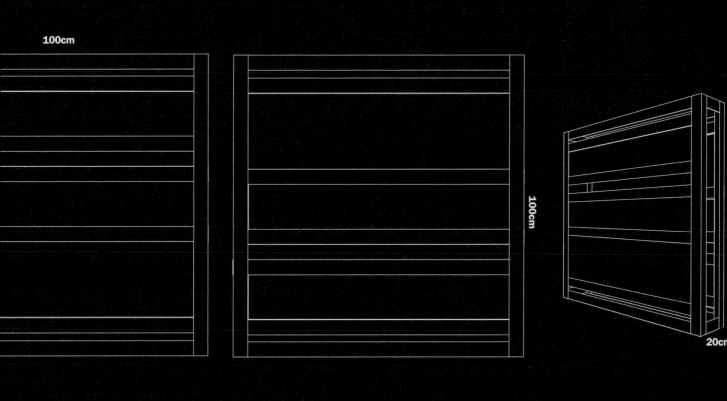

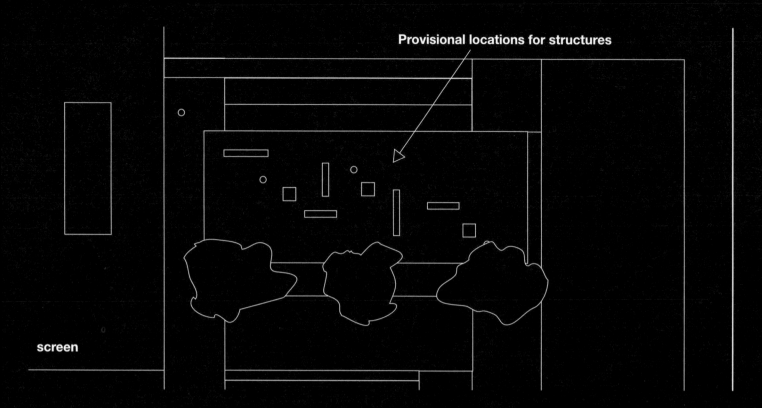

Provisional locations for structures

screen

et is 5mm thick
two complete shelving structures in the completed work
module in the structure is 50cm x 50cm x 50cm (approx.)

TOTAL 00 UNITS

7001 silver grey
5014 pigeon blue
1003 signal yellow
2000 yellow orange
1014 dark ivory
3020 traffic red
5012 light blue

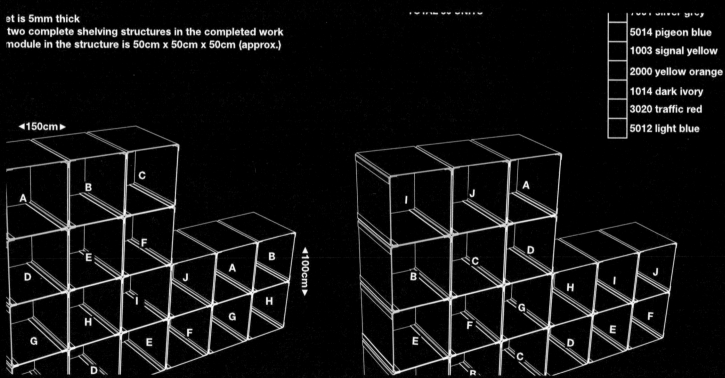

◀150cm▶

◀100cm▶

far right IN ORDER TO BE ABLE TO DRAW A LIMIT TO THOUGHT WE SHOULD HAVE TO FIND BOTH SIDES OF THE LIMIT THINKABLE… WE SHOULD HAVE TO THINK WHAT CANNOT BE THOUGHT. 2001 International Language, Belfast

◀40cm▶

40cm

◀8cm▶

5cm

slot is
6cm x 1cm

25cm

/doestheuniversea
rtohaveonetimean
espacedimensions

tersunk

aluminium/black text/helvetica

all text run together, centred aı

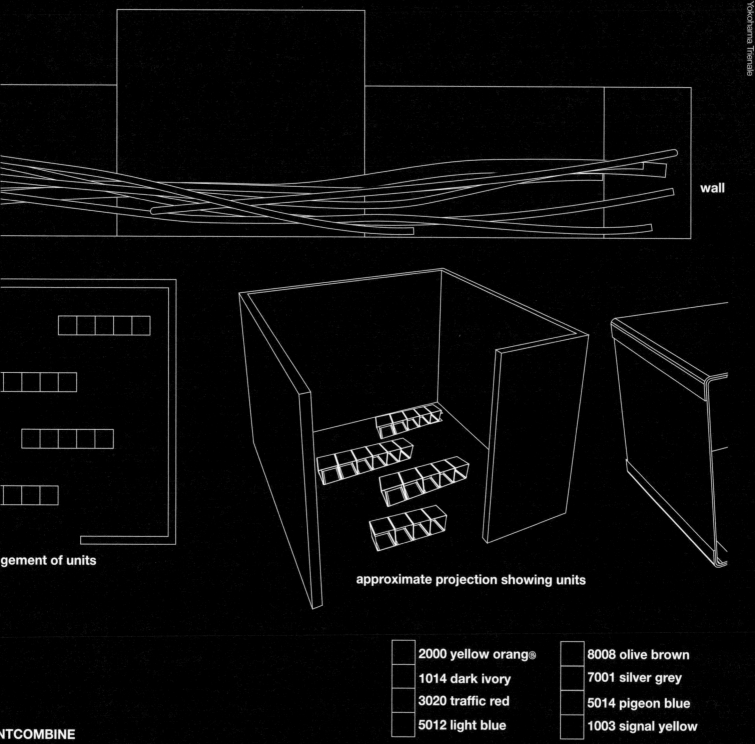

wall

gement of units

approximate projection showing units

NTCOMBINE

2000 yellow orang℮	8008 olive brown
1014 dark ivory	7001 silver grey
3020 traffic red	5014 pigeon blue
5012 light blue	1003 signal yellow

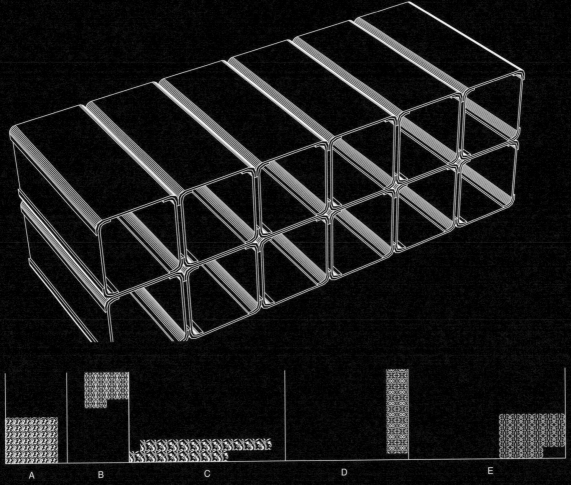

4 feet

A B C D E

All walls mirrored with diagram/decoration as screenprinted black design

D

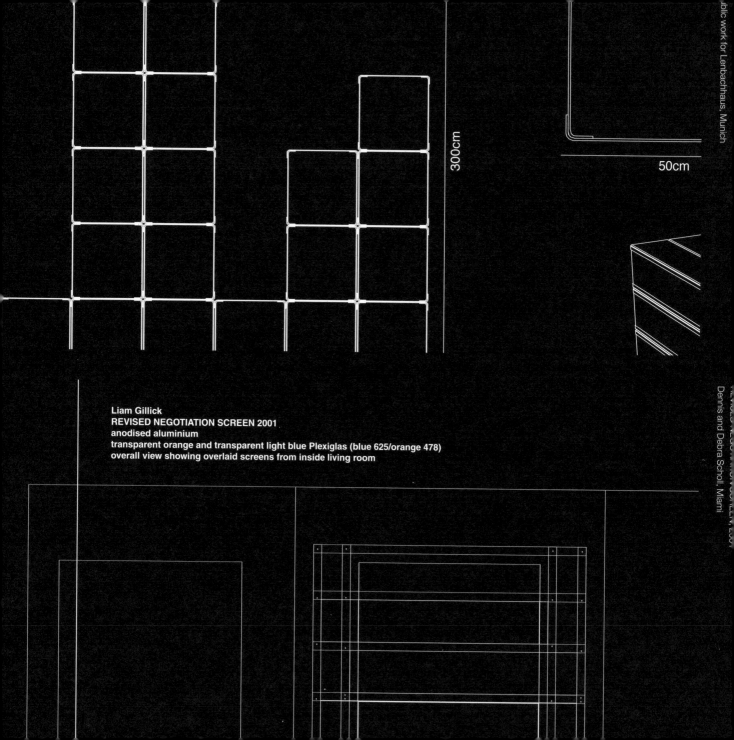

300cm

50cm

Liam Gillick
REVISED NEGOTIATION SCREEN 2001
anodised aluminium
transparent orange and transparent light blue Plexiglas (blue 625/orange 478)
overall view showing overlaid screens from inside living room

IDEA HORIZONS, 2002
Curtain wall for Ft. Lauderdale/Hollywood International Airport, Florida

eveningcoolandeveningcoolevening cool

lesssky

glidingbyglidingbyandglidingbyglidingbyandglidingbyglidingbyandglidingbyglidingbyandglidingby

swoopandgraceandswoopgraceandswoopandgraceandswoop

sunsetpauseandsunsetpausesunsetpauseandsunsetpause

blueandsmoothandblue

skimmingspeedandskimn

sweptcurrentsandsweptcurrentssweptcurrentsandsweptcurrents

ctfish

intenseandcalmandintensea

Liam Gillick/Ft. Lauderda
Final Proposals for Preser
Project Title: IDEA HORIZ
technique: Digitally Image
GENERAL OVERVIEW 2 (I
© Liam Gillick 2002

approx 1000cm

UNIVERSITÄT HEIDELBERG/Neubau für das Otto-Meyerhof-Zentrum
AREY YOUNG/Oktober 2000
IOT TO SCALE
E PURPOSES ONLY/NOT TO SCALE

ULTRASTRUCTURES (WITH CAREY YOUNG), 2000
Proposal for Universität Heidelberg

GILLICK/YOUNG/ULTRASTRUCTURES/PROJECTION 1/SHE

Liam Gillick/Carey Young
DECISIONS TREE/2000
for BO 01
Medborgarplatsen

66.
The Wood Way
Liam Gillick

Liam Gillick/Carey Young

DECISION TREE/2000
for BO 01
Medborgarplatsen

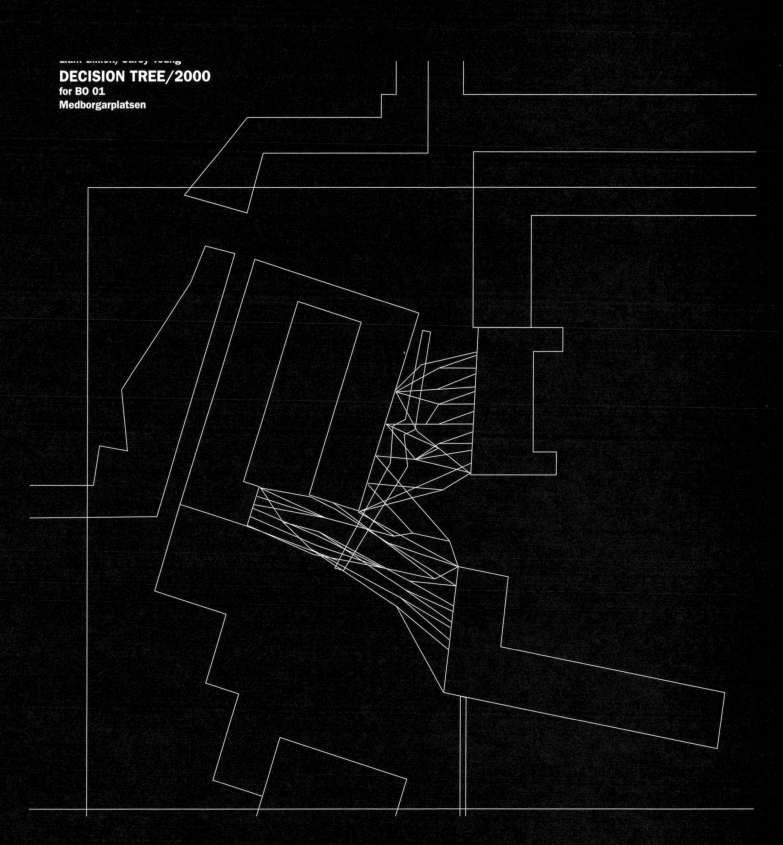

View of all screens together

typical screen front (from main hall) typical screen rear (from library) typical screen when viewed together

DESIGN FOR A PRIVATE APARTMENT, PARIS, 2000

alorslesgens
étaient-ilsa
brutisàcepoint
avantlatélévision?

sliding screens
for window wall

wall painted with lobby diagram
covering door to bedroom 2, bathroom and bedroom 3

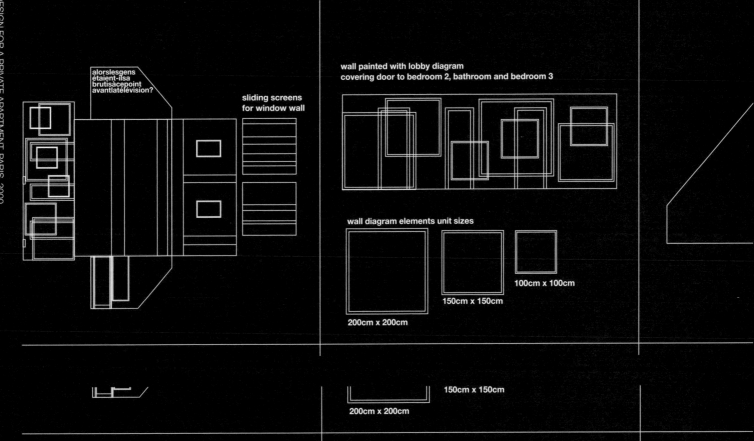

wall diagram elements unit sizes

100cm x 100cm

150cm x 150cm

200cm x 200cm

150cm x 150cm

200cm x 200cm

alorslesgens
étaient-ilsa
brutisàcepoint
avantlatélévision?

sign-written text on right hand wall
"So were people this dumb before television?"
Neue Helvetica Bold

double shelf for length of wall

carpet in two colours
double shelf in melamine

Renovation of privat
For E/M & L
Liam Gillick 2000

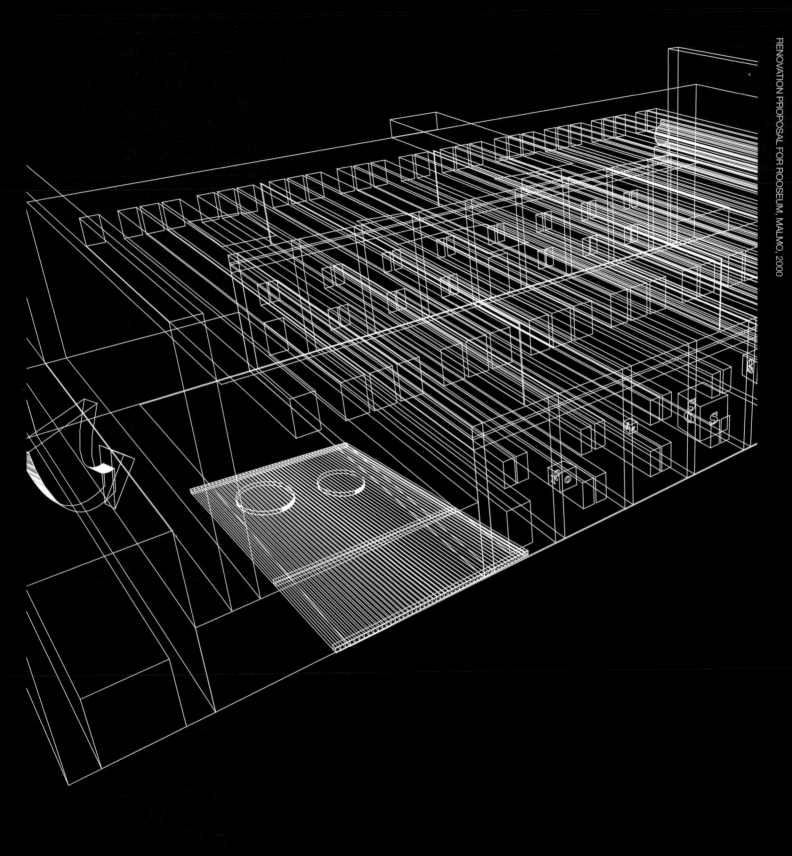

70.
The Wood Way
Liam Gillick

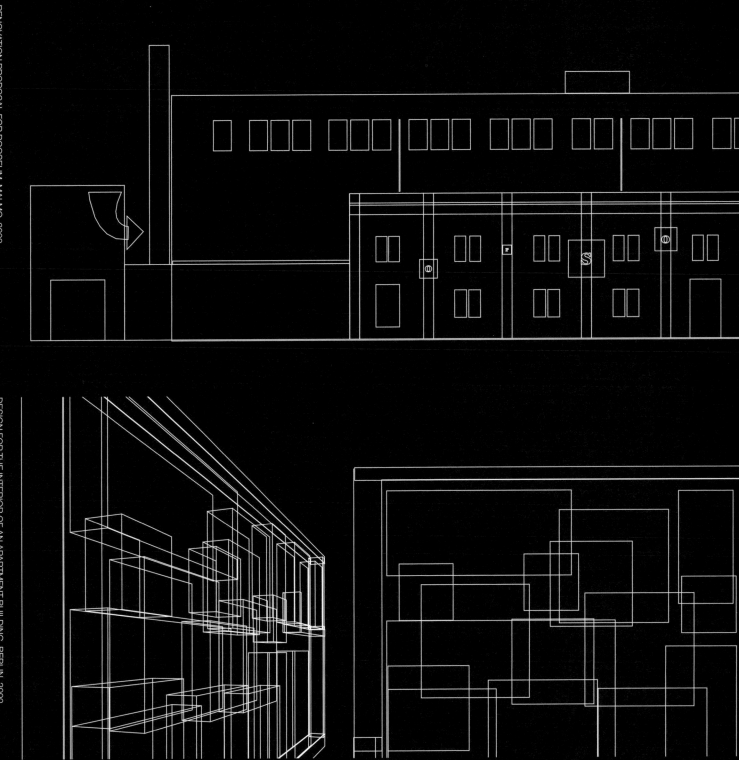

Walther Koenig Books Ltd.
at the Serpentine Gallery

Serpentine Gallery, Kendington Gardens, London W2 3XA

Tel: +44 (0)20 7706 4907 Fax +44 (0)20 7706 4911 email: waltherkoenigbooks@hotmail.com

© Liam Gillick 2002

72.
The Wood Way
Liam Gillick

far left DEDALIC CONVENTION (WITH ANNETTE KOSAK), 2001
Poster design, MAK, Vienna

left GRAPHIC FOR CARTIER, 2002
Glamour Engineering, Zurich

Wir bitten zur Ausstellung/We cordially invite you to the exhibition/Deda
Dienstag, 18. September 2001, 20.00 Uhr/Tuesday, September 18, 2

Von/By Liam Gillick and Annette Kosak und/and Peio Aguirre, Julie Aul
Trisha Donnelly, Richie Hawtin, Stefan Kalmar, Gabriel Kuri, Scott Olso
Markus Weisbeck, Pae White, mit/with Daniela Zyman, Hildegund Am

WEAREDETERMINEDTOCONDEMNEME
lick 2000
nyl text on wall/helvetica bold

20cm City

youaretobedrawnonahurdlethroughtheCityofLondontoTyburntheretobehangedtil
youarehalfdeadafterthatcutdownyetaliveyourbowelstakenoutofyourbodyand
burnedbeforeyouyourprivypartscutoffyourheadcutoffyourbodytobedividedinto
fourpartsandyourheadandbodytobesetatsuchplacesastheKingshallassign

thebastard
thebastard

So Steven Spielberg
heaven and meets G
and Gabriel says "Gre
God really loves your
anything you need, y
your man." and Steve
know, I always wante
Kubrick. Do you think
that?" and Gabriel loo
"You know Steven, o
could ask for, why wo
that? You know that S
take meetings." "Well
there was anything I v
Gabriel says "I'm reall
that." So now he's sr
around heaven and S
guy with a beard, we
jacket, riding a bicycle
to Gabriel, "Oh my G

left BAG DESIGN FOR WALTHER KOENIG BOOKS LTD, LONDON, 2002

n Gillick
LDEN BEACH TRANSPOSITION
0
ch towel
out could be adjusted to
nan language)

adaywithnosunisnight

felt for slip-mats and hand-
hand-made objects

production of music
Something to put under
Something to us

my step was light and I could feel the ball of each fo

78.
The Wood Way
Liam Gillick

right LITERALLY NO PLACE, 2002
Book cover design, Book Works, London

Literally No Place
Communes Bars
and Greenrooms
Liam Gillick
Book Works
London

far right BRIDGE THE GAP, 2002
Book cover design, CCA, Kitakyushu

bridge the gap

akiko miyake

hans ulrich obrist

cca kitakyushu

THE SEMIOTICS OF
THE BUILT WORLD
Liam Gillick

These extracts are taken from responses to questions from Lionel Bovier, Jan Estep, Annie Fletcher, Mark Francis, Søren Grammel, Akiko Miyake, and Haegue Yang

DISTRACTION

There are a number of keys to understanding my work; one is distraction. Following this distracted line, you might consider the following example: I was supposed to be doing an exhibition for the Frankfurter Kunstverein and initially I ended up going to South London to search for a location for a film that did not need making. Artists have the opportunity to get involved in distracted displacement exercises like this because in the end, if you are a DJ, you have to work within music. You can have different details and different combinations and different ways to present music, but in the end it is very difficult for a DJ to turn up and avoid playing records. What I like about the position of an artist is that you might start out intending to be a DJ and end up cleaning the floor with vodka and glitter instead.

RETINAL

It is important to try and play with the idea of a retinal experience as different to a textual narrative experience. We use different parts of the brain when we write a critical analysis and when we make an arrangement of physical objects. I try to keep on a borderline between narrative-based research and the presentation of objects and images that flicker in and out of significance in relation to broader manipulations of our socio-political landscape.

ISOLATION

I never really believed the idea of an artist working in isolation, because I knew that it is not possible. Even from a very young age, I was suspicious of anything that mythologised the idea of an artist as a lone person. I was never interested in the idea of an artist who is

an outsider. Arguments towards isolation were always put forward by people whose politics were such that it would be to their advantage to accentuate the idea of an artist as a rogue individual. The situation at Goldsmiths (in the mid-eighties) was complex because everyone discussed the idea of collective activity and context and how artistic character is formulated – how it is controlled, disseminated and understood. Many ideas around the formulation of artistic persona were talked about yet they were rarely understood as critical metaphors. Certain people claimed the analysis as an actual working model. In these cases, discussion was understood as a recipe for how to be successful, rather than an analytical examination of a better way to understand art. I was always sceptical about the early over-determination of my work as art or my own identity being over-determined as artist-like and the other way around. Part of the reason why this was possible is that I emerged by historical accident during a dynamic period. What is interesting about any dynamic moment when two or more people decide to become involved in a similar activity is that it also allows room for other people to play in-between those who want to characterise the situation. These halfway figures can meander around rather over-determined work and self-definition.

TIME LAGS

I'm interested in management structures and I'm curious about the way corporations or think tanks organise themselves in relation to the way art is contextualised. You inevitably become involved in a critique of both forms when you are making art-like objects and thinking about ideas that will sustain interest. While not focusing on how the nebulous art world in general is operating, I am thinking a great deal in parallel to organisational structures in general although I'm not particularly interested in illustrating them in my work.

RESOLUTION

The work is not a resolved or complete statement, it is speculative working material – a way of checking to see if a place that once had a function, both socially and cine-matically, can still hold a narrative or be a potential site for the shooting of new fictions.

AVOIDANCE

I have tried to avoid the production of autonomous work derived from a series of singular questions. I am much more interested in a non-linear or non-progressive working technique that involves the development of a series of parallel strategies. Despite having attended an art school that operated on a post-Bauhaus model, I have always tried to avoid posing myself the question "What is the idea behind this work?" As a result I have developed parallel working practices that don't necessarily intersect at any predictable moment. The moment of exhibition doesn't mean the point of conclusion but nor does it mean the exposure of work in progress. Instead, during an exhibition, there might be many different moments in the development of a set of thinking. The old 'documentary versus fiction' binarism might be a good analogy. My work flicks between documentary and fiction, sometimes involving the production of artificial settings where documentary material can be played out. To some extent, my working technique is a corruption of the subject and a corruption of authorship in an attempt to address the problems thrown up by the broad centre of social and political thought without using the same techniques that are common in the worlds alongside art.

SCENARIOS

Scenarios are written to fulfil very specific requirements. I want to address quite abstract socio-political constructs that are not within visual art alone. It seems quite normal to start by writing many notes on many blank sheets of paper rather than by making one drawing on one sheet at a time.

LOCALE (RELATIONAL AESTHETICS)

The work is produced with a specific location in mind. It could be as marginal as constructing shelving that fits in a particular place, but could be moved to another place. It is not built-in. This is crucial in relation to the ideas at the centre of the texts, which deal with the semiotics of the built world in terms of temporary adjustment, the language of renovation and the ideology of change. The materials I use are non-fundamental and not used in order to create basic structure. There is no single idea behind the books either, so the writing and the retinal work all deal with different aspects related to issues of compromise, strategy, negotiation and renovation. The work you see in the gallery or in specific applied situations is functioning in parallel, both to itself, other similar work and to the texts I use.

ASSOCIATIVE

The work in the gallery is not a resolution of form and content, but is associative, discursive and parallel to the text. Sometimes I think that I am making work that operates best in relation to other structures and other art rather than standing alone. Maybe the work even functions best if you stand with your back to it and think about something else.

SPECIFIC DECORATION

One of the things that affects any straight man of my age is the influence of reconsiderations of style, design, decoration and craft inherent in critiques of gender specificity. A critical phrase used to be 'this is a bit designy or a bit decorative'. In common with many people of my generation I embraced certain aspects of design as part of a critique of established terms of judgement within an art context. The problem now is relational – how to absorb and play with the coding of the built world, while not forgetting to keep reconstructing a condensed core of ideas that can be constructive rather than purely reflective.

BINARY OPPOSITIONS

There is very little sense of consolidation in my work. The ideas and various realisations float free and operate as parallel strands. I do not spend much time creating binary oppositions. It is important for me to operate in relation to the built world. My interests lie in how shifting concepts of ethics and conscience find form in the built world. This is the basis of the book LITERALLY NO PLACE (2002). The book attempts to address what happens when speculation becomes the dominant tool in defining our urban environment. In order to do this it is important that I engage with the real built environment. As a result, I am happy attempting to write a loaded and contradictory text while at the same time engaging in work for airports, traffic systems, and other applied situations that expose and test the complexities at the core of what I am doing.

IDEALISM FINDING FORM

Idealism is not a problem, depending on how idealism finds form, location, and execution. I am interested in renegotiating the varied ideologies that form the built world. We live in a time in which the language of creative thought has been appropriated by the most dynamic corporations, so it is often hard to identify the points at which artists become clear markers in society. There are many corrective moments in my work that exist to skew any simplistic readings of what art can be. For example, a glass of Seven-Up is placed at the edge of an otherwise concrete and precise display of objects in order to undermine formalist readings. These corrective gestures carry precise ideological pointers. An example would be my design of new Entryphone systems and mailboxes for the earliest public housing in Brussels. This is a didactic and functional work in the context of my output that usually focuses on its mutability of meaning. If there is a plea for a better situation, then it is embedded in the work. There is a constant attempt to avoid a coquettishness that might place the work in an irrelevant frame of reference. While I admire artists who construct 'better' visions of how things might be, the middle-ground, negotiated territories

I am interested in always carry the possibility of moments where idealism is unclear. There are as many demonstrations of compromise, strategy, and collapse in my work as there are clear recipes for how our environment can be better. Everything I do runs alongside other structures that exist in the world, so it must at times exhibit the same problems and concerns of that world.

RECENT PAST AND NEAR FUTURE

Despite appearances, my work has little conscious reference to high Modernism. I am more interested in the recent past and near future. Any given moment that appears to carry an excess of idealism was loaded up with the contrary. High Modernism, for example, runs alongside the emergence of fascism, banking, and corporate development. The counter-cultures of the 1960s had to fight against brutal intolerance, a massive arms race, ongoing suburbanization, and the proliferation of tranquilisers. Our present situation has its share of idealism and its shadow. It could be argued that every period requires and possesses its own focused and dynamic forms of idealism which are not all immediately apparent. Generalised forms of idealism can be as important as focused ones, although it is crucial to find forms of idealism that are neither absolutist nor falling into sluggish relativism.

UGLY LANGUAGE

Contemporary idealism takes many forms. Some of the ugliest examples are appropriated from the languages and ideas of earlier progressive moments but are used for completely different ends. International relativism, which attempts to work across cultures and ideologies, has been squashed by a sense of righteous justice that creates its own new problems. There are moments in art where a sense of idealism has to be challenged and kept in check. The notion of idealism as a self-sufficient abstract concept is not enough. The role of the artist is to be as vigilant about the construction of forms of idealisms as about the way exhibitions are put together, mediated, and understood.

PARADOX AND LIBERALISM

The paradoxes inherent in my work reveal certain threads that parallel the matrix of ideas that circulate in culture in general. In this respect, it is worth reconsidering the classic liberal position. As there is a critique of the centre ground, both socially and politically, in the work, there is also both a critique of liberalism within the echoes of liberal ideologies. At some level I am negotiating the idealism of others, which is an activity with its own specific history. We are surrounded by dynamic reworkings of English language; generally these changes and shifts are absorbed by the dominant management culture. So you could argue that I am working against a kind of neo-liberalism while challenging relativism and trying to avoid getting caught up within the same language games. In order to do this I must reclaim and play with some of those modes of language and behaviour. As such, I remain interested in literary modes of complexity and idea development. I am not sure what to think about speculation winning over planning. I am not a ruralist or focused on Utopias. My idealism is rooted in discussion, negotiation, and the examination of compromised states.

FRAGMENTS OF PRODUCTION

I have deliberately created multiple entry points into the ideas around my work. There is also a condensed core of ideas that has been created through the writing of short books. It must be remembered that a great deal of the work is light and lacks consolidation, like cleaning the floor with vodka and glitter. This work must be considered alongside the more identifiable screens, installations, and realisations. At the heart of the work is a constructed and gradualist relation to many of the ideas I am considering at any one time so I would expect others to have a slow and gradual, relational view of the work too. Specific moments catch certain people and hold attention for a moment, while for others, it is the whole matrix of ideas that is important.

GENERALISED SPECIFICITY

An important part of my work is connected to aesthetic play. I have found that it often functions best in relation to other art, objects, and situations. It becomes activated in relation to specific architecture rather than the generalised gallery space. The look of the work plays with the idea of the 'rescued location' and 'de-designated space'. There is something quite apparent about the idea of working with overhead panels and platforms as these tend to designate space. They withdraw from your eye line when you are closest to them, so that they float overhead while projecting a subtle presence that alters the colour of shadows. They operate quite delicately with important residual effects.

FLICKERING IDEOLOGY

When my work operates best, it is in a constant state of flux between perception states, like a flickering sense of function, ideology, and art. The titles of the works exist for many different reasons and are varied, but many of them operate as rhetorical tools, to reclaim certain territories and to find a way to address some middle-ground ideas. If you do this while avoiding didactic 'information room' art, you end up with some notional space where certain ideas are set in motion, rather than over-determined and described to death. It is never a clear-cut pragmatic issue, but there are clearly designed moments that are different from art but not quite incorporated into the language of the built world. My work stands as a series of markers that offer a temporary series of non-places that only function

because the viewer or user of the work is bringing some applied ideas to bear on what they are passing by or considering. This sounds very abstracted, but as long as you remember that the work is addressing how the near future is controlled in a post-utopian situation, then you can see both the problem inherent in its construction and the potential when it works.

PUBLIC HOUSING
My work is about using certain ideas around design to understand the construction of ideology in relation to the built world. In the last couple of years I have started working on a number of applied works (commissions for airports, public housing, and social environments) that have shifted my relationship to architecture and design. In these situations I am forced into close proximity with the world of advanced building semiotics that I am both critical of and embrace. This tends to heighten the issue of design in relation to my work as it means that I am in contact with people in parallel to art, who are thinking hard about how to make a place work. In these situations the art aspect of my work tends to be sublimated by the functional critique that is part of my project. It is here that the work enters the realm of the quasi-functional so that it doesn't fall into certain marginalised traps inherent in the placement of public art. For example, I might design a new set of tinted windows for an airport in Florida or a new traffic system for Porsche in the middle of Stuttgart. You could argue that all my work to date has worked towards a time when a city might ask for my contribution to a

discussion about how to deal with the ideological collapse at the centre of our neo-liberal urban environments.

PROVISIONAL PROTOTYPE
The texts I write or use perform a specific element of the work and operate in different ways to the other objects, ideas, and propositions. The function of elements of text within the artworks is to accentuate the ideological base of the ideas. Importantly I also used words like 'prototype' and 'provisional' in the titles of the works. The text could be seen as part of a larger scene-setting concept, an attempt to de-emphasise the art-ness of the work, and to put across the projected nature of my thinking. More recently the texts have come loose from these more nuanced uses and operate alone as work in relation to other work. There are many differences between each text work – they are never produced in a series or as part of some ongoing neo-conceptual project.

LITERALLY NO PLACE
LITERALLY NO PLACE has the subtitle COMMUNES, BARS AND GREENROOMS. It concerns the story of three people leaving and returning to a desert-based commune. Once back, they each have the task of telling a story. Each story must outline an environment in which ethical shifts have affected the look and feel of the place. Questions of conscience come up and the text slowly begins to break down. Each speaker continues until they have begun to outline a dichotomy. Once things become binary the story moves on. They develop narratives that could be simultaneously described as significant and marginal. These address the urban/non-urban, the border zone, and the locations of pre and post presentation. Tin mining, Hotel California, and throwing spoons across bars in Tokyo all feature in a text that indicates the collapses

inherent in any attempt to pin down the shifting state of our urban structures. Where the book DISCUSSION ISLAND/BIG CONFERENCE CENTRE (1997) could be described as encompassing a certain degree of observed amorality, LITERALLY NO PLACE attempts to address some of the implications of those same issues but in terms of the way revised notions of ethics and conscience find form in the built world.

GREY AREAS
Artists should try to find grey areas, which are harder to expose and occupy, despite the rhetoric surrounding neo-liberal business practice. Working without being purely aesthetic or purely formalist is one option, but it is the world of settings and décor that I am really interested in. The creation of provisional structures carries temporary ideological shifts. I am interested in reversal processes, where you are not using art to tell a story but you are using it to play with certain conditions that might be working towards or derived from narrative structures. It is possible to apply varied conditions to assess what happens each time. The introduction of an incomplete character (such as Erasmus Darwin) replaces the artist with another personality who can operate in the space alongside the trace left by the artist. This also allows for the presence of the viewer who is subsequently operating in this space. All of this reveals the influence on my work of artists like Philippe Parreno and Rirkrit Tiravanija, who opened up for me the notion of reading an exhibition as a film in real time.

PARALLEL THINKING
Everyone knows that the way art is visualised is the result of some parallel thinking. Therefore, it is very hard to hide the initial impulse that led you to do something or to disguise the ideology behind it. Some people you meet have particular ideas, beliefs and politics and it is very hard for them to hide these constructs in the formal realisation of their artwork. There might be something inherently conservative within what they are doing even if it appears quite abstract and open on first viewing and vice versa. If people look at things as purely an arrangement of objects in a space within a set of art values, they will discover that certain things have been undermined. They will not get an indication of resolution;

they will get a series of markers and provisional structures.

CINEMA NON-CINEMA
It would not be useful to create a functional film-set, but it is interesting to use a certain parallel thinking in order to create a slightly different quality of scenario-based artwork. If I am interested in film at all, it is in pre-production and post-production, not in the process of directing or shooting. I am interested in planning, mapping and the process of deciding how and what you do afterwards; when you are reprocessing and replaying a scenario. That kind of mentality produces a particular kind of half-object that can function quite well as an object that has significance. This is not because it has an 'auratic' value or seeks to project essentialist concepts or because of a neo-Duchampian application of meaning to temporarily un-art-like structures.

THE SOCIOLOGY OF
THE ART WORLD
My work with Henry Bond was always based on an understanding that Henry is extremely sceptical about the accepted route that an artist is supposed to take, the accepted speed of that route and the accepted forms for the dissemination of ideas. I have always been interested in sociological structures so I am inevitably interested in the sociology of the art world. It's a constant negotiation, as Henry always said, trying to operate around a search towards identification of any given emergence of fixed contextual structure. Working outside Britain, in France and Germany was very

important because I found situations where the critical and curatorial contexts were very strong but the perception, certainly in the early nineties, was that it might be hard to find artists in the same league. Britain was producing a lot of artists in a very weak critical and curatorial context. It was possible to travel and work outside Britain and for me to find the extra, added, element that was absent in my work before. My work has always been rather brittle and fragile in terms of consolidation so I've always found it more useful to work in a strong critical context. I've had to negotiate and play with the idea that once you become an artist, the tendency is to become more of an artist. It's what you could call a 'becoming' situation. If you're involved with critical writing for example, there is very little structural or social pressure to keep going. The pressure is all on becoming more and more of an artist. So if you're an artist who has done some writing and organising and other things alongside art, then the art identity of the work tends to dominate. Surprisingly enough, that is the thing you have to keep in check. A lot of people's rhetoric is about the defence of art or the defence of the right to be able to make art or show art, but ironically the difficulty is not so much how to continue being an artist but how to not stop being involved in the other things that you are genuinely interested in alongside art.

SEMI-AUTONOMOUS
Once I am offered a gallery space, I am let loose in a semi-autonomous zone which is already coded with various meanings, histories and understandings on the part of the visitor. The reason why I like to work in galleries as much as anywhere else is that you could view the gallery as a kind of laboratory where one might assume a level of knowledge or preparedness on the part of the visitor. This is useful when juxtaposed against text, which has a precise life outside the gallery space. The

exhibition is normally the working time, not the holiday time. Traditionally the moment of exhibition meant the completion of work or the beginning of a vacation away from the central ideas of the artist. Exhibitions involve setting a scene and putting things into play that can operate in parallel to the built environment around us. Alongside an interest in social projection and planning at the centre ground of social and economic behaviour, I am primarily interested in de-coding the semiotics of the built world. I am not interested in producing fundamental things or feelings that attempt to find equality with other fundamental things and feelings. I am more involved in the addition and subtraction to and from existing social structures, literal, metaphorical and actual.

FULLY AUTONOMOUS
I have always been sceptical about over-determining the role of an artist as an autonomous author. My approach to this always seems to be in line with other cultural areas that I am interested in from architecture to contemporary music. In most of these parallel areas the author is named but the work is the result of collaborative activity where everyone is clearly credited for what they have done. The discussions I have always been interested in work better when they are not pursued in isolation. Working with others plays a corrective role and introduces elements of discussion that would be internalised if you were working alone. Yet it is important to point out how different all these collaborations can be. With Sarah Morris I work more as an employee or commissioned person, providing music for her films. She makes the films; I produce the music. It is not a heavily discursive process. With Philippe Parreno the process is often only discursive, with very little actual work being produced. Both examples are crucial. The first for limiting the borders of the work and the second for exploding them.

CONDENSED CORE
The most important function of writing has been the creation of a condensed core of parallel ideas that make it possible to avoid a simple relation between intentions and results. This is extremely important in terms of the artist's obligation to critical space. Artists operate at all points within a critical discourse, even if they pretend they don't.

In order for the critical process to become dynamic it must be seen as something more than just another kind of 'art'. On one level we can tolerate this fetish complex of the artist as author, as scientist or as whatever. Yet we have to address the notion of the artist as a 'refuser', apparently resisting the critical discourse. You have to exploit the potential of a certain zone that is contradictory to the production of an artist and that continually problematises the tendency of structures to become binary, crudely oppositional and definable by default.

MID-CENTURY

It is arguable that with the advance of mid-century modernism and the attendant Greenbergian focus upon the object and the technique rather than the viewers' intellect, ideology or beliefs, we experienced a continuing perception of the materiality of an artwork as a source of potential. An increasing displacement of the viewers' own ideas and necessity to absorb the ideas of the artist and the potential of the art itself developed with the secularisation of art. In other words, the viewers' knowledge of theology and sense of belief was transfered to art when it was primarily in the service of religion. The reduction of the viewers' belief complicated the relationship between the user and the producer. Architecture and design suffered a concurrent hollowing out as potential carriers of profundity. Buildings and design were actually and potentially functional and worked mainly as a 'default factor' within the art discourse, as a judgement tool against which to define what art might

be. It was common to judge the success or failure of a painting in relation to its escape from decoration and design and a sculpture in terms of its avoidance of theatricality and architectural tendencies. It is arguable that terms like modern and post-modern mean something subtly different to an artist and an architect and nothing at all to some designers. We are faced by a crisis of analysis as much as by a crisis of form, structure or intention. Architecture and interior design were starved of the application and search for meaning and profundity while art suffered from an excess of potential and a perceived lack of significance. The analysis of one or other area was not retarded, just different. They emerged, interacted and diverged at many non-synchronised moments.

THE EIGHTIES

In the 1980s we were used to dealing with ideas of the sign and a half digested understanding of Baudrillard mixed with a sort of pragmatising American liberalisation of theory. I remain interested in the skill and technical issues faced by those who make real signs. I am interested in how they behave and what they feel is possible and impossible once people stop looking at their production in relation to art. Their work has absorbed all of the deconstructive potential of recent semiotic thought, even if they are not overtly aware of it.

REFUSAL

Art is a place where you can develop modes of refusal that are qualitatively and ideologically different from the production and negotiation of other objects and ideas in the world. As such art is not a bad place to heighten contemporary discussions of the way we relate to each other and to the places we occupy or are forced to operate within. Many artists take a cultural form of the Fifth Amendment. By doing this they allow the work to sit as the location of

complexity, contradiction and beauty that is necessary to create alternative visions of the world. The danger is that it is easy to slip into rhetorical structures that bear no relation to the way the work is used and perceived. There are moments when the conceptual discourse at the heart of the work overwhelms the lightness of the art 'stuff'. But you could also argue that the multiple entry points into the work overwhelm any singular reading. Art becomes a problematic once people assume that it might carry more inherent significance than any other complex structure in the world. When you are primarily operating as an artist there tends to be an assumption of potential and particularity. As a result, it is important for artists to resist the process of 'artisting' in order to correct the over-application of meanings that inevitably happens in a culture where anyone involved in the creation of images and ideas starts to think of themselves as an artist. In common with most artists, I am interested in issues other than art. Art is a convenient term for a mind-space location where you don't need cultural permission to carry out certain corrective tasks in relation to society in general.

EXHIBITIONS

Exhibitions are places where visitors occupy a specific type of negotiable location. This is very different to the classic late-modern idea that the visitor completes an exhibition. Actually the place is activated by people in the sense that the work does not necessarily function best as an object for consideration alone. It is sometimes a backdrop or décor rather than a pure content provider. Self-perception has changed in the one hundred years since the development of cinema and the subsequent arrival of television. Self-image has been heightened for long enough that we no longer sense it, which doesn't mean that self-awareness has improved, it has just been shared. We have a reflected sense of an image of ourselves in space while we carry out certain tasks. For example, children sometimes commentate on their actions while they play sport. This is related to classical role-playing, and stems from a sense that we can picture someone else watching an image of ourselves as we take part in something.

SITES

It is important to find another way of looking at the question of site-specificity, which is a bogus construction in a contemporary context. If you start thinking in terms of applied art instead you might be able to redefine spaces. The work is not an installation and it is not site-specific but thinking has been applied to a specific place or set of concepts and vice-versa.

CONSTRUCTED PERSONA

It is now debatable whether or not any given formulation of the way an artist could choose to work would be interesting. I'm not convinced that it's productive for an artist to work alone, with another person, in a group, in one group containing many groups or with a lot of postal workers. But the curatorial situation is much more complicated. It's in a more dynamic phase and by that I don't necessarily mean that it's inherently better or more exciting or easier to work as a curator but historically it is in a sequence of moments of development, change and challenge. It's not the old binarism that existed when you talk to certain people of a certain age and they speak about a division of responsibility, where the artist and curator role is distanced and clear-cut. A lot of the critique around curating is coming from curators. I am inevitably interested in this situation, which remains open to change. I'm happy to collaborate with people on the reformulation of how to organise and think about cultural production, which is basically what curating tends to be. My involvement goes from one extreme to the other. I'm involved with all forms of that rethinking because

what's great about being an artist now is that you have the luxury of working at a time when curatorial dynamism means that you can enter into many types of structures with your work. You don't have to remain isolated or focused; you can enter ideas on a series of rhizomic (multiple and constantly reconnecting) levels.

FETISH AND SCEPTICISM

I'm quite sceptical about what happened in Britain with this fetish for artist-organised projects although the situation can now be read as part of a sequence of productive projects. The suggestion was that those exhibitions were somehow more real or had more meaning or were inherently better. The trick is to retain a kind of vigilance and scepticism about all of these things. It's interesting that in Britain the idea of losing the context or losing the curators was very attractive at a certain point. People would say, "Oh it's the artists who have done it." But in fact, most of the time the artists were using a reassuring curatorial set of techniques that were already well established and all they were doing was appropriating a conservative curatorial model. The danger is of overly determining the discussion towards the artist-orientated drive. There is a certain kind of coquettishness with rather conservative curators who are the first ones to stand up and say, "It's wonderful and I think the artists should just be doing the exhibitions themselves and all of the curators should stop." That's the worst possible scenario. It's not the point. The contemporary context is not improved by removing the potential for critique. It's about revising new forms. I'm very wary of any attempts to claim that it would be more interesting to have a consistently autonomous artistic practice. I don't believe that it's possible and I think it has a weakening effect.

PARALLEL ACTIVITIES

It is productive for me to view all activities in parallel to each other. The idea of curating in isolation does not interest me as much as the potential of shifting the source and process of production, reception and discussion. What interests me a great deal is the way that people whose primary work is curating are constantly refining their role. Curating is in a dynamic historical phase so any thoughts I have about my own role in relation to other artists is affected by my awareness of the adjustments to the sense of artistic practice that is constantly being challenged and updated by curators rather than artists.

DELUSION

I am quite interested in the potential of delusion in the sense that an artist ought to be able to take on certain tasks without waiting for cultural permission. In the past, I worked like an architect, a designer and a journalist. I still find this displacement activity useful yet to make an artistic commentary upon the look of a particular architecture alone is unproductive. To put yourself in the role of thinking: "Can I return to a place (such as Thamesmead housing estate in South London – location of Kubrick's CLOCKWORK ORANGE) and make an effective search for the starting point of a new form of film?" – might provide more useful results. It would introduce questions around ideological re-modelling as well as structural reassessment.

DEAREST DIARY

The film DEAR DIARY has a scene where Nanni Moretti is riding around Rome on his moped talking about various problems, including the housing projects that were built on the outskirts of Rome in the 1960s and 1970s. He talks about how they have a bad reputation, how no one really likes them, and then you realise that he is on his way to see them. As he pulls up outside an enormous housing estate he is near the end of his monologue. He glances at the building and then looks back at the camera. To our surprise, he just shrugs, says things don't look as bad as they could be and then rides back into town.

MORE CINEMA

In some ways cinema is one of the grave disappointments

of the 20th century in terms of the way it has become formalised. But the experience and potential of cinema is completely different. I quite like Walter Benjamin's idea about distraction, architecture and cinema. I have similar feelings in the sense that I am more interested in the way architecture is the place where you are distracted and cinema can create the necessary focus for that distraction. The two are intimately connected and generate disappointment and anticipation in equal measure. For artists, focusing on these areas can be difficult because many are interested in ideas relating to architecture and cinema without really reflecting upon the problematic inter-relation of those interests. The combination of making films and then building places to show them in created very particular kinds of social space, which hadn't existed before, but were similar to something which had existed before, i.e. theatre. I was at art school when a lot of people were trying to work out what they thought about the combination of nostalgia for cinematic potential and an interest in the unfocused distracted locations of modern architecture. Of course THE BRUNSWICK CENTRE in London, a public housing project incorporating an independent cinema, is the classic meltdown of the ideological space between cinema and architecture that artists have recently found so productive. For some artists, cinema still has the mythical audience that many of them think they would like to have; it has that intelligent, visually literate audience. It also has a mass audience that artists would like. So some artists decided to cut the crap

and go straight to the source and not to impose a kind of matrix of art values over the use of cinematic ideas. They just removed the structural bit or the problematic games with cinema and made mini-movies instead. My work is different. It is a social verification process carried out in a state of distraction. It is pre-production and post-production with a missing centre.

DISAPPOINTMENT
Cinema and art are one of those double acts, which provoke endless bad seminars, dull conferences and boring exhibitions based on art and something similar. The desire to enter the world of mainstream cinema is extremely attractive to artists who have flirted with the meanings generated by the medium. Art and science is one double act. Art and cinema is the other. Art and architecture are often joined, but these apparently natural combinations create the most complicated relationships, so have to be constantly renegotiated and re-checked in terms of the social relations they provide. My real interest is in the built world or the constructed world, rather than in just architecture or just cinema. I have as much interest in architecture as anyone else, but I am not looking at architecture in isolation from the ideology that creates it and is generated by its use. I have been trying to play with the gap between presentation and narrative: physical structures of debatable consolidation in parallel with other ideas.

MISUNDERSTANDING
A lot of people had an understanding of Post-modernism that was entirely based on an ironic recognition of the failure of Modernism. That is not entirely my position, although it doesn't mean that I am an unquestioning apologist of brutal architecture either. I am somewhere in between. I am interested in negotiating the shifting ideology of the built world in a post-

planning situation. You could say that one of the great ideological battles of the 20th century was not just between the political left and right in their abstract forms, it was also a fight between speculation and planning. What happens when speculation is basically the dominant form within the Western world and what happens when planning is in the hands of speculators? Speculators now plan the centre of Berlin, whereas it had always been a location of the fight between speculation and planning. What is interesting about THAMESMEAD 1, the first part of an enormous housing project in south London, is that it remains an area with formal integrity because it is the result of planning, but all around it the city council has set in motion the conditions where speculation can now take place. Speculation has been made easy in terms of planning regulations and the purchase of land. So now the original THAMESMEAD location is surrounded by mock-Tudor Barratt homes. These changes carry very clearly inscribed ideological messages. A site that was a swamp in 1965 is now the ultimate demonstration of social change.

COLLAPSE
The Thatcherite-inspired collapse of the social system resulted in the deconstruction of symbolic unified acts on behalf of city councils and communities. What you see in Thamesmead is that the detailing has been altered because people are now allowed to do it. Not necessarily because they own their flat or building, but because they are now in that post-Thatcher situation which allows them to have a Georgian front door instead of a standard orange one. While on one level, Thamesmead appears to be a dead place where you can design your own coffin, it is also a negotiated space which carries the traces of the soft ideological confrontations of our recent past, all framed and filtered through the overstated memory of Kubrick's movie. (CLOCKWORK ORANGE)

NOT AT HOME
A few years ago I read the proofs of a book that ended up being published under the title NOT AT HOME: THE SUPPRESSION OF DOMESTICITY IN ART AND ARCHITECTURE and I was struck by the references to Le Corbusier. The book offers a number of critical essays about high-modernist architectural practice from the

perspective of our corrected politics. Corbusier's famous quote about demanding a new kind of quasi-industrial domestic space that would be commensurate with the aspirations of the twentieth century male value system seemed to be a key statement in relation to the development process of my new book, LITERALLY NO PLACE. I presented this phrase in Korea as a starting point and a historical quotation. The words were all strung together into one long new word to ensure that it took a little time to absorb the full potential of the quotation and turned it into one long neo-German compound word. The quote had some resonance in relation to the architecture there and the constant shifts in Korean social and political life. It is simultaneously a starting point and the end of a discussion. It is an amazingly sexist quote that couldn't be articulated in the same way today, yet it is still implicit in certain contemporary architectural spaces. It is like a corrupted motivational saying that you might find in revised form within books on business management.

LIAM GILLICK
Born 1964, Aylesbury, U.K.
Lives and works in London and New York

EDUCATION
1983/84 Hertfordshire College of Art
1984/87 University of London, Goldsmiths College

ONE-PERSON EXHIBITIONS

1989 84 DIAGRAMS, Karsten Schubert Ltd, London.
1991 DOCUMENTS (with Henry Bond), Karsten Schubert Ltd, London.
 DOCUMENTS (with Henry Bond), A.P.A.C., Nevers.
 DOCUMENTS (with Henry Bond), Gio' Marconi, Milan.
1992 McNAMARA, HOG BIKES AND GRSSPR, Air de Paris, Nice.
1993 DOCUMENTS (with Henry Bond), CCA, Glasgow.
 AN OLD SONG AND A NEW DRINK (with Angela Bulloch), Air de Paris, Paris.
1994 McNAMARA, Schipper & Krome, Cologne.
 DOCUMENTS (with Henry Bond), Ars Futura, Zurich.
 LIAM GILLICK, Interim Art, London.
1995 IBUKA! (PART 1), Air de Paris, Paris.
 IBUKA! (PART 2), Kunstlerhaus, Stuttgart.
 IBUKA!, Galerie Emi Fontana, Milan.
 PART THREE, Basilico Fine Arts, New York.
 DOCUMENTS (with Henry Bond), Kunstverein ElsterPark, Leipzig.
1996 ERASMUS IS LATE 'VERSUS' THE WHAT IF? SCENARIO, Schipper & Krome, Berlin.
 LIAM GILLICK, Raum Aktuelle Kunst, Vienna.
 THE WHAT IF? SCENARIO, Robert Prime, London.
 DOCUMENTS (with Henry Bond), Schipper & Krome, Cologne.
1997 DISCUSSION ISLAND, Basilico Fine Arts, New York.
 DISCUSSION ISLAND - A WHAT IF? SCENARIO REPORT, Kunstverein, Ludwigsburg.
 A HOUSE IN LONG ISLAND, Forde Espace d'art contemporain, L'Usine, Geneva.
 ANOTHER SHOP IN TOTTENHAM COURT ROAD, Transmission Gallery, Glasgow.
 MCNAMARA PAPERS, ERASMUS AND IBUKA REALISATIONS, THE WHAT IF?
 SCENARIOS, Le Consortium, Dijon.
 RECLUTAMENTO!, Emi Fontana, Milan.
1998 LIAM GILLICK, Kunstverein in Hamburg.
 UP ON THE TWENTY-SECOND FLOOR, Air de Paris, Paris.
 WHEN PURITY WAS PARAMOUNT, British Council, Prague.
 BIG CONFERENCE CENTER, Orchard Gallery, Derry.
 LIAM GILLICK, Robert Prime, London.
 RÉVISION: LIAM GILLICK, Villa Arson, Nice.
 WHEN DO WE NEED MORE TRACTORS?, Schipper & Krome, Berlin.
 LIAM GILLICK, c/o Atle Gerhardsen, Oslo.
1999 LIAM GILLICK, Kunsthaus Glarus, Glarus.
 LIAM GILLICK, Rüdiger Schottle, Munich.
 "DAVID", Frankfurter Kunstverein, Frankfurt.
2000 LIAM GILLICK, Galleri Charlotte Lund, Stockholm.
 LIAM GILLICK, Schipper & Krome, Berlin.
 CONSULTATION FILTER, Westfälischer Kunstverein, Münster.
 SCHMERZ IN EINEM GEBÄUDE, Fig 1, London
 WOODY, CCA Kitakyshu.
 LITERALLY NO PLACE, Air de Paris, Paris.
 RENOVATION FILTER, RECENT PAST AND NEAR FUTURE, Arnolfini, Bristol.
 LIAM GILLICK, Casey Kaplan, New York.
2001 FIRSTSTEPCOUSINBARPRIZE, Hauser & Wirth & Presenhuber, Zurich.
 LIAM GILLICK, Javier Lopez, Madrid.
 LIAM GILLICK, Corvi-Mora, London.
 ANNLEE YOU PROPOSES, Tate Britain, London.
 DEDALIC CONVENTION, Salzburg Kunstverein.
2002 THE WOOD WAY, Whitechapel Art Gallery, London.

PROJECTS

1992 THE SPEAKER PROJECT, ICA, London.
INSTRUCTIONS, Gio' Marconi, Milan.
1995 FACTION, Royal Danish Academy of Arts, Copenhagen.
STOPPAGE, CCC, Tours.
STOPPAGE, Villa Arson, Nice.
THE MORAL MAZE, Le Consortium, Dijon.
1998 THE TRIAL OF POL POT, (with Philippe Parreno), Le Magasin, Grenoble.
1999 OLDNEWTOWN, Casey Kaplan, New York.
2000 ITSAPOORSORTOFMEMORYTHATONLYNUNSBACKWARDS,
Goldsmiths College, London.
2001 DEDALIC CONVENTION, (with Annette Kosak) MAK, Vienna.
DEDALIC CONVENTION/DU UND ICH (with Gary Webb), Salzburger Kunstverein.
2002 DARK SPRING (with Nicolaus Schafhausen), Kraichtal, Stiftung Ursula Blickle.

BOOKS BY THE ARTIST

1995 ERASMUS IS LATE, Book Works, London.
IBUKA!, Stuttgart, Kunstlerhaus
1997 DISCUSSION ISLAND/BIG CONFERENCE CENTRE, Derry/Ludwigsburg,
Orchard Gallery/Kunstverein Ludwigsburg.
ERASME EST EN RETARD, Dijon, Les Presses du Réel.
MCNAMARA PAPERS, ERASMUS AND IBUKA REALISATIONS, THE WHAT IF?
SCENARIOS, Dijon, Le Consortium, Hamburg, Kunstverein.
1998 L'ÎLE DE LA DISCUSSION/LE GRAND CENTRE DE CONFÉRENCE, Dijon,
Les Presses du Réel.
EDWARD BELLAMY, EIN RÜCKBLICK AUS DEM JAHRE 2000 AUF 1887,
(with Matthew Brannon), Leipzig, Galerie für Zeitgenössische Kunst.
1999 CALENDER, Glarus, Kunsthaus.
2000 THE BOOK OF THE 3RD OF JUNE, Kitakyushu, CCA.
FIVE OR SIX, New York, Lukas & Sternberg
LIAM GILLICK, Cologne, Oktagon.
2002 LITERALLY NO PLACE: COMMUNES, BARS AND GREENROOMS,
Book Works, London.

SELECTED GROUP EXHIBITIONS

1990 THE MULTIPLE PROJECTS ROOM, Air de Paris, Nice.
1991 NO MAN'S TIME, CNAC, Villa Arson, Nice.
AIR DE PARIS À PARIS, Air de Paris, Paris.
THE MULTIPLE PROJECTS ROOM, Air de Paris, Nice.
1992 TATOO, Air de Paris/Urbi et Orbi, Paris/Daniel Büchholz, Cologne/
Andrea Rosen, New York.
MOLTEPLICI CULTURE, Folklore Museum, Rome.
LYING ON TOP OF A BUILDING THE CLOUDS LOOK NO NEARER THAN THEY
HAD WHEN I WAS LYING IN THE STREET, Monika Sprüth, Cologne/Esther
Schipper, Cologne/Le Case d'Arte, Milan.
MANIFESTO, Daniel Büchholz, Cologne/Castello di Rivara, Turin/Wacoal Arts Centre,
Tokyo/Urbi et Orbi, Paris.
ETATS SPÉCIFIQUE, Musée d'art moderne, Le Havre.
12 BRITISH ARTISTS, Barbara Gladstone /SteinGladstone, New York.
GROUP SHOW, Esther Schipper, Cologne. ON, Interim Art, London.
1993 TERRITORIO ITALIANO, Milan.
CLAIRE BARCLAY, HENRY BOND, RODERICK BUCHANAN, LIAM GILLICK, ROSS
SINCLAIR, Gesellschaft für Aktuelle Kunst, Bremen.
TRAVELOGUE, Hochschule fur Angewandte Kunst, Vienna.
LOS ANGELES INTERNATIONAL, Esther Schipper at Christopher Grimes,
Los Angeles.
WONDERFUL LIFE, Lisson Gallery, London.
GROUP SHOW, Esther Schipper, Cologne.
THE LONDON PHOTO RACE, Friesenwall 120, Cologne.

FUTURA BOOK, Air de Paris, Nice.
POINTS DE VUE, Galerie Pierre Nouvion, Monaco.
MANIFESTO, Hohenthal und Bergen, Munich.
BACKSTAGE, Kunstverein in Hamburg.
TWO OUT OF FOUR DIMENSIONS, Centre 181, London.
DOKUMENTATION UBER, ARBEITEN VON, Esther Schipper, Cologne.
UNPLUGGED, Cologne.
1994 DON'T LOOK NOW, Thread Waxing Space, New York.
BACKSTAGE, Kunstmuseum Luzern.
SURFACE DE RÉPARATIONS, FRAC Bourgogne, Dijon.
COCKTAIL I, Kunstverein in Hamburg.
PUBLIC DOMAIN, Centro' Santa Monica, Barcelona.
GRAND PRIX, various locations, Monaco.
RUE DES MARINS, Air de Paris, Nice.
MECHANICAL REPRODUCTION, Galerie van Gelder, Amsterdam.
WM/KARAOKE, Portikus, Frankfurt.
OTHER MEN'S FLOWERS, Hoxton Square, London.
MINIATURES, The Agency, London.
DAS ARCHIV, Forum Stadtpark, Graz.
LOST PARADISE, Kunstraum, Vienna.
SURFACE DE RÉPARATIONS 2, FRAC Borgougne, Dijon.
THE INSTITUTE OF CULTURAL ANXIETY, ICA, London.
1995 MÖBIUS STRIP, Basilico Fine Arts, New York.
BAD TIMES, CCA, Glasgow.
IN SEARCH OF THE MIRACULOUS, Starkmann Library Services, London.
COLLECTION FIN XX, FRAC Poitou Charentes, Angouleme.
SUMMER FLING, Basilico Fine Arts, New York.
KARAOKE, South London Art Gallery.
IDEAL STANDARD SUMMERTIME, Lisson Gallery, London.
RESERVE-LAGER-STORAGE, Oh!, Bruxelles.
FILMCUTS, Neugerriemschneider, Berlin.
NEW BRITISH ART, Museum Sztuki, Lodz.
BRILLIANT, Walker Art Centre, Minneapolis.
TRAILER, Mediapark, Cologne.
1996 CO-OPERATORS, Southampton City Art Gallery, Southampton.
TRAFFIC, CAPC, Bordeaux.
KISS THIS, Focalpoint Gallery, Southend.
MARCH À L'OMBRE, Air de Paris, Paris.
DEPARTURE LOUNGE, The Clocktower, New York.
EVERYDAY HOLIDAY (with Gabriel Kuri), Le Magasin, Grenoble.
DER UMBAU RAUM, Künstlerhaus, Stuttgart.
DINNER, Cubitt Gallery, London.
SOME DRAWINGS FROM LONDON, Princelet Street, London.
NACH WEIMAR, Landesmuseum, Weimar.
HOW WILL WE BEHAVE?, Robert Prime, London.
ESCAPE ATTEMPTS, Globe, Copenhagen.
LIFE/LIVE, ARC, Musée d'Art Moderne de la Ville de Paris, Paris.
SUCH IS LIFE, Serpentine London/Palais des Beaux Arts, Brussels/
Herzliya Museum of Art.
ITINERANT TEXTS, Camden Arts Centre, London.
LOST FOR WORDS, Coins Coffee Store, London.
ALL IN ONE, Schipper & Krome, Cologne.
A SCATTERING MATRIX, Richard Heller Gallery, Los Angeles.
FOUND FOOTAGE, Tanja Grunert & Klemens Gasser, Cologne
GLASS SHELF SHOW, ICA, London.
SUPASTORE DE LUXE, Up & Co., New York.
LIMITED EDITION ARTIST'S BOOKS, Brooke Alexander, New York.
1997 LIFE/LIVE, Centro Cultural de Belém, Lisbon.
TEMPS DE POSE, TEMPS DE PAROLE, Musée de l'Echevinage, Saintes
DES LIVRES D'ARTISTES, l'école d'art de Grenoble.
AJAR, Galleri F15, Jeløy.
ENTER: AUDIENCE, ARTIST, INSTITUTION, Kunstmuseum Luzern.
SPACE ODDITIES, Canary Wharf Window Gallery, London.

MOMENT GINZA, Le Magasin, Grenoble.
I MET A MAN WHO WASN'T THERE, Basilico Fine Arts, New York.
504, Kunsthalle Braunschweig.
DOCUMENTA X, Kassel.
ENTERPRISE, ICA, Boston.
GROUP SHOW, Robert Prime, London.
IRELAND AND EUROPE, Sculptors Society of Ireland, Dublin.
GROUP SHOW, Vaknin Schwartz, Atlanta.
HEAVEN - A PRIVATE VIEW, PS1, Long Island.
HOSPITAL, Galerie Max Hetzler, Berlin.
KUNST. . . ARBEIT, SüdWest LB, Stuttgart.
OTHER MENS' FLOWERS, The British School at Rome, Rome.
MAXWELL'S DEMON, Margo Leavin, Los Angeles.
WORK IN PROGRESS AND OR FINISHED, Ubermain, Los Angeles.
GROUP SHOW, Air de Paris, Paris.
GROUP SHOW, Schipper & Krome, Berlin.
1998 LIAM GILLICK, JOHN MILLER, JOE SCANLAN, RAK, Vienna
FAST FORWARD, Kunstverein in Hamburg.
ARTIST/AUTHOR: CONTEMPORARY ARTISTS' BOOKS, American Federation of
Arts touring show Weatherspoon Art Gallery, Greensboro/The Emerson Gallery,
Clinton/ The Museum of Contemporary Art, Chicago/Lowe Art Museum, Coral
Gables/Western Gallery, Bellingham/ University Art Gallery, Amherst.
INTERACTIVE, Amerada Hess, London.
A TO Z, The Approach, London.
CONSTRUCTION DRAWINGS, PS1, New York.
ARENA - SPORT UND KUNST AUSTELLUNG, Galerie im Rathaus, Munich.
INGLENOOK, Feigen Contemporary, New York.
IN-SIGNIFICANTS, various locations, Stockholm, Sweden.
KAMIKAZE, Galerie im Marstall, Berlin.
LONDON CALLING, The British School at Rome & Galleria Nazionale
d'Arte Moderna, Rome.
FUORI USO '98, Mercati Ortofrutticoli, Pescara.
VIDEOSTORE, Brick and Kicks, Vienna.
UK - MAXIMUM DIVERSITY, Galerie Krinzinger, Bregenz/Vienna.
THE EROTIC SUBLIME, Thaddaeus Ropac, Salzburg.
ENTROPY, Ludwigforum, Aachen.
PLACES TO STAY 4 P(RINTED) M(ATTER), Büro Friedrich, Berlin.
WEATHER EVERYTHING, Galerie für Zeitgenössische Kunst, Leipzig.
ODRADEK, Bard College, New York.
MISE EN SCÈNE, Grazer Kunstverein, Graz.
MINIMAL-MAXIMAL, Neues Museum Weserburg, Bremen; Kunsthalle, Baden-
Baden; CGAC, Santiago de Compostela.
GHOSTS, Le Consortium, Dijon.
DIJON/LE CONSORTIUM.COLL, Centre Georges Pompidou, Paris.
CLUSTER BOMB, Morrison Judd, London.
THE PROJECT OF THE 2ND DECEMBER, Salon 3, London.
PROJECTIONS, de Appel, Amsterdam.
1+3 = 4 × 1, Galerie für Zeitgenössische Kunst, Leipzig.
1999 KONSTRUCTIONSZEICHNUNGEN, Kunst-Werke, Berlin.
PL@YTIMES, École supérieure d'art de Grenoble, Grenoble.
XN, Maison de la culture, Chalon.
CONTINUED INVESTIGATION OF THE RELEVANCE OF ABSTRACTION, Andrea
Rosen Gallery, New York.
NÜR WASSER, Neumühlen, Hamburg.
12 ARTISTS, 12 ROOMS, Galerie Thaddeaus Ropac, Salzburg.
AIR DE PARIS: WORKS BY AND/OR INFORMATIONS ABOUT, Grazer Kunstverein.
TANG, Turner and Runyon, Dallas.
PLUG-INS, Salon 3, London.
ETCETERA, Spacex Gallery, Exeter.
OUT OF SIGHT - A CROSS-REFERENCE EXHIBITION, Büro Friedrich, Berlin.
ESSENTIAL THINGS, Robert Prime, London.
LABORATORIUM, Antwerpen Open, Antwerp.
IN THE MIDST OF THINGS, University of Central England, Bourneville.

LE CAPITALE, Centre régionale d'art contemporain, Sête.
THE SPACE IS EVERYWHERE, Villa Merkel, Esslingen.
OBJECTHOOD OO, Athens.
TENT, various locations, Rotterdam.
DCONSTRUCTIVISM: LIFE INTO ART, Brisbane.
SHOPPING, FAT, London.
FANTASY HECKLER, Tracey, Liverpool Biennial.
ART LOVERS, Tracey, Liverpool Biennial.
TRANSMUTE, MCA Chicago.
NEW YORK/LONDON, Taché-Levy, Brussels.
GET TOGETHER/ART AS TEAMWORK, Kunsthalle, Vienna.
1999 EAST WING COLLECTION, Courtald Institute of Art, London.
JONATHAN MONK, Casey Kaplan, New York.
705 WINGS OF FREEDOM, Berlin.
OFFICINA EUROPA, Bologna.
UNE HISTOIRE PARMI D'AUTRES, FRAC Nord-Pas de Calais.
SPACE, Schipper & Krome, Berlin.
2000 29TH INTERNATIONAL FILM FESTIVAL, Rotterdam.
CONTINUUM 001, CCA, Glasgow.
STORTORGET I KALMAR, Statens Konstråds Galleri, Kalmar.
MEDIA CITY 2000, Seoul.
GROUP SHOW, Casey Kaplan, New York.
WIDER BILD GEGENWART. POSITIONS TO A POLITICAL DISCOURSE, RAK, Vienna
14 + 1, Feitchtner & Mizrahi, Vienna.
DECOMPRESSING HISTORY, Galeri Enkehuset, Stockholm.
VIVA MARIA III, Galerie Admiralitätsstraße, Hamburg.
BRITISH ART SHOW 5, Touring Exhibition,
Edinburgh, Southampton, Cardiff, Birmingham.
DIRE AIDS, Art in the Age of Aids, Promotrice delle Belle Arti, Torino.
WORKING TITLE, Stanley Picker Gallery, Kingston University.
PREFIGURATION OF THE MUSEUM OF CONTEMPORARY ART, TUCSON (AZ).
COLLECTION JRP, Kunsthalle Fribourg.
WHAT IF/TÅNK OM, Moderna Museet, Stockholm.
INTERPLAY, The National Museum of Contemporary Art, Oslo.
GROUP SHOW, Paula Cooper Gallery, New York.
INTELLIGENCE, Tate Britain, London.
FUTURE PERFECT, Centre for Visual Arts, Cardiff.
HAUT DE FORME ET BAS FONDS, FRAC Poitou-Charentes, Angoulême.
VICINATO 2, Fig. 1, London.
VICINATO 2, Neuggerreimschneider, Berlin.
WERKLEITZ, Tornitz.
WILDER BILD GEGENWART, POSITIONS TO A POLITICAL DISCOURSE,
Nieuw Internationaal Kultureel Centrum, Antwerp.
PERFIDY, La Tourette, Eveaux.
PROTEST AND SURVIVE, Whitechapel Art Gallery, London.
E-MONA, The Museum of New Art, Detroit.
AUSSENDIENST, Kunstverein in Hamburg.
INDISCIPLINE, Roomade, Brussels.
QUE SAURIONS-NOUS CONSTRUIRE D'AUTRE? La Villa Noailles.
CASA IDEAL, Museo Alejandro Otero, Caracas.
MORE SHOWS ABOUT BUILDINGS AND FOOD, Oeiras, Hangar K7, Lisbon.
PERFIDY, Kettles Yard, Cambridge.
HOW DO YOU CHANGE AN APARTMENT THAT HAS BEEN PAINTED BROWN?
CERTAINLY NOT BY PAINTING IT WHITE, Institute of Visual Culture, Cambridge.
AUSSTELLUNG DER JAHRESGABEN, Westfälischer Kunstverein, Münster.
GROUP SHOW, Corvi-Mora, London.
FUTURE PERFECT, Cornerhouse, Manchester.
2001 CENTURY CITY, Tate Modern, London.
DEMONSTRATION ROOM: IDEAL HOUSE, Apex Art, New York.
HISTOIRE DE COEUR, Fondation Guerlain, Les Mesnuls.
FIG.1, London.
THERE'S GONNA BE SOME TROUBLE, A WHOLE HOUSE WILL NEED
REBUILDING, Rooseum, Malmö.

STOP AND GO, FRAC, Nord-Pas de Calais, Dunkerque.
FUTURE PERFECT, Orchard Gallery, Derry.
MINIMAL-MAXIMAL, City Museum of Art, Chiba; National Museum of Art, Kyoto; City Museum of Art, Fukuoka.
NOTHING, Northern Gallery for Contemporary Art, Sunderland/Contemporary Art Centre, Vilnius/Rooseum, Malmo.
CONTEMPORARY UTOPIA, Museum of Modern Art, Riga.
BERLIN BIENNALE, Kunst Werk, Berlin.
COLLABORATIONS WITH PARKETT: 1984 TO NOW, Museum of Modern Art, New York.
INTERNATIONAL LANGUAGE, Grassy Knoll Productions, various sites, Belfast.
A NEW DOMESTIC LANDSCAPE, Javier Lopez, Madrid.
THE WEDDING SHOW, Casey Kaplan, New York.
GEOMETRY AND GESTURE, Thaddeaus Ropac, Salzburg.
BIENNALE DE LYON, Musée d'art contemporain, Lyon.
A TIMELY PLACE, London Print Studio.
STRATEGIES AGAINST ARCHITECTURE, Fondazione Teseco, Pisa.
WALL DRAWINGS, Le Spot, Le Havre.
THE COMMUNICATIONS DEPARTMENT, Anthony Wilkinson Gallery, London.
AMBIANCE MAGASIN, Meymac Centre d'art Contemporain.
BEAUTIFUL PRODUCTIONS: PARKETT, Whitechapel Gallery, London.
DEMONSTRATION ROOM: IDEAL HOUSE, NICC, Antwerp.
YOKOHAMA 2001, Yokohama Triennale, Yokohama.
EVERYTHING CAN BE DIFFERENT, Jean Paul Slusser Gallery, University of Michigan /School of Art, Ann Arbor.
RUMOR CITY, Raffinerie, Brussels.
ANIMATIONS, PS1, Long Island City.
PARALLEL STRUCTURES, South Bank Corporation, Brisbane.
9E BIENNALE DE L'IMAGE EN MOUVEMENT, Centre pour l'image contemporaine, Saint-Gervais, Genève.
4 FREE, Büro Friedrich, Berlin.
RUMOUR CITY, TN Probe, Japan.
EN/OF, Schneiderei, Cologne.
INGENTING, Rooseum, Malmö.
`I LOVE DIJON, Le Consortium, Dijon.
....IF A DOUBLE-DECKER BUS CRASHES INTO US TO DIE BY YOUR SIDE SUCH A HEAVENLY WAY TO DIE AND IF A TEN TON TRUCK KILLS THE BOTH OF US TO DIE BY YOUR SIDE THE PLEASURE AND THE PRIVILEGE IS MINE..., Air de Paris, Paris.

2002 URGENT PAINTING, ARC, Musée d'art moderne de la ville de Paris, Paris.
PASSENGER: THE VIEWER AS PARTICIPANT, Astrup Fearnley Museum, Oslo.
NOTHING, Mead Gallery, Warwick.
J'EN AI PRIS DES COUPS MAIS J'EN AI DONNÉS AUSSI, Galerie Chez Valentin, Paris.
ART & ECONOMY, Deichtorhallen, Hamburg.
EVERYTHING CAN BE DIFFERENT, University of Memphis, Tennesee.
VOID, Rice Gallery, Tokyo/CCA Kitakyushu.
ANNLEE YOU PROPOSES, Mamco, Geneve.
STARTKAPITAL, K21, Dusseldorf.
PARALLEL STRUCTURES, Gertrude Contemporary Art Spaces, Fitzroy.
PRIVATE VIEWS, Printed Space, London.

SELECTED PUBLICATIONS

1991 DOCUMENTS, London and Nevers, One-Off Press and A.P.A.C.
NO MAN'S TIME, Nice, Villa Arson.
1992 MOLTEPLICI CULTURE, Rome.
12 BRITISH ARTISTS, Barbara Gladstone/Stein Gladstone, New York.
240 MINUTENS, Cologne, Esther Schipper.
INSTRUCTIONS, Gio' Marconi, Milan.
ON, London, Interim Art.
1993 TRAVELOGUE, Vienna, Hochschule für Angewandte Kunst, Vienna.
LOVE IS NO FOUR LETTER WORD, Cologne, Esther Schipper.

BACKSTAGE, Kunstverein, Hamburg.
IDEAL PLACE, Nevers, Les Presses du Réel.
1994 PUBLIC DOMAIN, Centro' Santa Monica, Barcelona.
OTHER MEN'S FLOWERS, FN/Booth-Clibborn, London.
THE INSTITUTE OF CULTURAL ANXIETY, ICA, London.
1995 MÖBIUS STRIP, Basilico Fine Arts, New York.
LOST PARADISE, Vienna/Stuttgart, Oktagen.
STOPPAGE (CD), CCC/Villa Arson, Nice, Tours and London.
COLLECTION FIN XX, FRAC Poitou Charentes, Angouleme.
WE ARE MEDI(EVAL), (WITH ANGELA BULLOCH), Portikus, Frankfurt.
NEW ART FROM BRITAIN, Museum Stzuki, Lodz.
SURFACE DE RÉPARATIONS, FRAC Bourgogne, Dijon, France.
BRILLIANT, Walker Art Centre, Minneapolis.
1996 TRAFFIC, CAPC, Bordeaux.
NACH WEIMAR, Cantz, Weimar.
LIFE/LIVE, Paris, Musée d'Art Moderne de la Ville de Paris.
BOOK WORKS - A PARTIAL HISTORY, London, Book Works.
ECHOES, New York, The Monacelli Press
1997 BLIMEY!, London, 21.
UNBUILT WORLDS: UNREALISED ARTISTS PROJECTS, Munster, Cantz
POLITICS AND POETICS, Kassel - documenta X, Cantz.
SHORT GUIDE, Kassel - documenta, Cantz.
ANDREAS SCHULZE, Kunstverein Ludwigsburg, Cantz.
MOVING TARGETS, Louisa Buck, London, Tate Gallery.
HOSPITAL, Berlin, Galerie Max Hetzler.
KUNST. . . ARBEIT, Suttgart, SudWest LB/Cantz.
1998 ARTIST/AUTHOR: CONTEMPORARY ARTIST'S BOOOK, New York, American Federation of Arts.
MINIMAL-MAXIMAL, Bremen, Neues Museum Weserburg.
CREAM, London, Phaidon Press.
LE COLONEL MOUTARDE DANS LA BIBLIOTÈQUE AVEC LE CHANDELIER, Eric Troncy, Dijon, Les presses du réel.
DIJON/LE CONSORTIUM.COLL, Dijon/Paris, Les presses du réel/ Centre Georges Pompidou.
1999 WEATHER EVERYTHING, Leipzig, Cantz/Galerie für Zeitgenössische Kunst.
ART AT THE TURN OF THE MILLENIUM, Cologne, Taschen.
ESTHÉTIQUE RELATIONELLE, Nicolas Bourriaud, Dijon, Les presses du réel.
LE CAPITALE, Sête, Centre regionale d'art contemporain.
REWRITING CONCEPTUAL ART, London, Reaktion Books.
2000 BRITISH ART SHOW 5, Touring Exhibition, London, Southbank Centre.
AUSSENDIENST, Hamburg, Kunstverein in Hamburg.
DIRE AIDS, ART IN THE AGE OF AIDS, Promotrice delle Belle Arti, Torino.
INTELLIGENCE, London, Tate.
MOVING TARGETS 2, Louisa Buck, London, Tate.
PROTEST AND SURVIVE, Whitechapel Art Gallery, London.
MEDIA CITY, Seoul.
RENOVATION FILTER, RECENT PAST AND NEAR FUTURE, Bristol, Arnolfini.
FRESH CREAM, London, Phaidon.
2001 CENTURY CITY, London, Tate Modern.
MORE WORKS ABOUT BUILDINGS AND FOOD, Oeiras, Hangar K7
NOTHING, London, August Publisher
PARKETT: COLLABORATIONS & EDITIONS SINCE 1984, New York, Museum of Modern Art.
BERLIN BIENNALE, Berlin.
METRONOME 7, London, Metronome.
ANNLEE YOU PROPOSES, London, Tate Britain.
WHAT DO YOU EXPECT FROM AN ART INSITUTION IN THE 21ST CENTURY, Paris, Palais de Tokyo.
EVERYTHING CAN BE DIFFERENT, New York, ICI.
NEUE KUNSTKRITIK, New York, Lukas and Sternberg.
ART CRAZY NATION, London, 21 Publishing.
YOKOHAMA 2001, Yokohama, Yokohama Triennale.
2002 METRONOME 8B., The Queel, London.

100 REVIEWS, London, Alberta Press.
MAGAZIN 6, Salzburg, Salzburger Kunstverein.
DARK SPRING, Kraichtal, Stiftung Ursula Blickle.

SELECTED REVIEWS

1991 Michael Archer, DOCUMENTS: Karsten Schubert Ltd, Artforum, March.
Giorgio Verzotti, NO MAN'S TIME, Artforum, November.
Eric Troncy, NO MAN'S TIME, Flash Art International, December.
Michael Archer, TECHNIQUE ANGLAISE, Artforum, December.

1992 Giacinto di Pietrantonio, BOND & GILLICK, Gio' Marconi, Flash Art, April.
Henry Bond & Liam Gillick, PRESS KITSCH, Flash Art, July/Aug.
Eric Troncy, LONDON CALLING, Flash Art International 165, July/Aug.
Giorgio Verzotti, NEWS FROM NOWHERE, Artforum, July/Aug.
Elizabeth Lebovici, L'ART PIEGE A L'ANGLAISE, Liberation, July 7.
Francesco Bonami, TWELVE BRITISH ARTISTS, Flash Art International, Nov.

1993 Jutta Schenk-Sorge, ZWOLF JUNGE BRITISCHE KÜNSTLER, Kunstforum 120.
INTERVIEW WITH LIAM GILLICK, Flash Art International, January.
Eric Troncy, WALL DRAWINGS & MURALS, Flash Art International, May.
Nicolas Bourriaud, MODELIZED POLITICS, Flash Art, Summer.

1994 ARTE GUERRERO, El Pais, March 14.
Christian Besson, SURFACE DE RÉPERATIONS, Flash Art, May/June.
Wolfgang Zinggl, TEE TRINKEN MIT KÜNSTLERN, Flater, October 28.
Mark Currah, Time Out, December.

1995 Michael Hauffen, DAS ARCHIV, Kunstforum, January.
Nicolas Bourriaud, POUR UNE ÉSTHETIQUE RELATIONNELLE, Documents, No. 7.
Sabine Maida, SUR UN AIR DE DARWIN, Paris Quotidien, May 15.
Philippe Parreno, UNE EXPOSITION SERAIT-ELLE UN CINÉMA SANS CAMÉRA?,
Liberation, May 27.
Liam Gillick, KUNSTLERPORTRÄTS, Neue Bildende Kunst, June-August.
Eric Troncy, LIAM GILLICK, Flash Art International, Summer.
ERASMUS IS LATE, La Repubblica, September 15.
Christoph Blase, IBUKA!, Springer, Issue 4.
LIAM GILLICK, New York Times, December 8.
Anne Doran, PART THREE, Time Out, New York, Dec 13 - 20.

1996 Brigitte Werneburg, DAS VIRUS HEIßT POLITICAL CORRECTNESS,
Taz, 9/10 March.
Barbara Steiner, IF...IF...IF... A LOT OF POSSIBILITIES, Paletten, No. 223.
Philippe Parreno, McNAMARA - A FILM BY LIAM GILLICK, Paletten, No. 223.
Andreas Spiegl, TRAFFIC - CAPC, Art Press, No. 212, April.
Hans Knoll, PARALLELWELTEN UND FROTTIERTE SCHILDE,
Der Standard, 18 April.
LIAM GILLICK, Der Standard, 2 May.
Martin Herbert, LIAM GILLICK, Time Out, May 15 - 22.
Lars Bang Larson, TRAFFIC, Flash Art, Summer, No. 189.
Jennifer Higgie, LIAM GILLICK, Frieze, Issue 30.
Barbara Steiner, FILM AS A METHOD OF THINKING AND WORKING,
Paletten, No. 224.
Pierre Restany, NEW ORIENTATIONS IN ART, Domus.

1997 Jesse Kornbluth, IS SOUTH BEACH BIG ENOUGH FOR TWO HOTEL KINGS?,
New York Times, 16th Feb.
UBERLIEFERTES AUFBRECHEN, Neue Luzerner Zeitung, 12th April.
Gregory Volk, LIAM GILLICK AT BASILICO FINE ARTS, Art in America, June.
DOCUMENTA X, various press.
Eric Troncy, WE'RE PEOPLE THIS DUMB BEFORE TELEVISION: INTERVIEW WITH
LIAM GILLICK, Documents sur l'art, No.11
Christoph Tannert, ZWISCHEN HOSPITAL UND HOTEL,
Berliner Zeitung, Dec 20th.

1998 Susanne Gaensheimer, IN SEARCH OF DISCUSSION ISLAND,
Index, No.22, February.
Karl Holmquist, HOSPITAL, Flash Art March/April.
Jade Lindgaard, LE PLEXIGLAS PHILOSOPHICAL,

Le Monde/Les Inrockuptibles, 6th to 12 May.
Laura Moffatt, LIAM GILLICK, Art Monthly, July/Aug.
Ken Johnson, INGLENOOK, New York Times, 24th July.
Eric Troncy, LIAM GILLICK/VILLA ARSON, Les Inrockruptiles, Summer.
PAUL CASSIRER KUNSTPREIS, Berlin Morgenpost, Sept 30th.
Anders Eiebakke & Bjønnulv Evenrud, LIAM GILLICK, Natt & Dag, Dec/Jan.

1999 Roberta Smith, CONTINUED INVESTIGATION OF THE RELEVANCE OF
ABSTRACTION, New York Times, Feb 12.
Thomas Wolff, NA LOGO, Frankfurter Rundschau, March 31st.
Andrea K. Scott, CONCEPTUAL ART AS NEUROBIOLOGICAL PRAXIS,
Time Out, New York, April.
Ronald Jones, A CONTINUING INVESTIGATION INTO THE RELEVANCE OF
ABSTRACTION, Frieze, Issue 47, Summer.
LIAM GILLICK, Neue Zürchner Zeitung, July 9.
Martin Engler, VERSPÄTETES MILLENNIUM, Frankfurter Allgemeine, July 21.
Nikolaus Jungwirth, Erzengel Spielberg, GOTT KUBRICK UND EINE BLUTIGE
MARIA, Frankfurter Allegemeine, Sept 21.
Christian Huther, RAUMFANTASIEN RUND UM STANLEY KUBRICKS FILME,
Frankfurter Morgenpost, Sept 23.
LIAM GILLICK, Sud Deutsche Zeitung.
Michael Hierholzer, EIN GERÜST FÜR DIE STOFFE DER PHANTASIE,
Frankfurter Allgemein, Nov 3rd.
WHAT IS ART TODAY?, Beaux Arts Magazine, Dec.

2000 Jörg Heiser, DISCO/DISCONTENT, Frieze, March.
Michael Wilson, APPLIED COMPLEX SCREEN, Art Monthly, March.
Petra Noppeney, MYSTERIÖSE MULTIPLEXPLATTEN,
Westfälischer Nachrichten, March 25.
Liam Gillick, ACHTUNG, DIESE STADT WIRD NORMAL,
Frankfurter Allgemeine, March 27th.
WHAT IF, Contemporary Visual Arts, Issue 28.
Nicolas Siepen, DER KERN ZERSTREUT SICH, Frankfurter Allgemeine, April 3.
Daniel Birnbaum, WHAT IF, preview, Artforum, May.
Hans Hedberg, ESTETISKT VAKTOMBYTE UTAN UDD,
Svenska Dagbladet, May 13.
Johan Schloemann, BAU MIR EINEN SCHUHLADEN, Frankfurter Allgemeine, July 24.
Egna Tolkningar, EN SVALT SOFISTIKERAD UPPVISNING, Norrländska
Socialdemokraten, Aug 2.
Ina Blom, WHAT IF?, Frieze 54.
Andrew Mead, CALLED INTO QUESTION, The Architects Journal, Nov 8.
David Musgrave, LIAM GILLICK, Art Monthly 241, November.
John Tremblay, TOP TEN, Art Forum, November.
Dean Inkster, DÉFENCE DE LA LECTURE, LE PROCÈS DE POL POT,
Art Press, Special No.21.
Jennifer Higgie, FUTURE PERFECT, Frieze, Issue 55.
Michael Wilson, LIAM GILLICK, Untitled, Dec.
Daniel Birnbaum, WHAT IF, Artforum, Dec.
Liam Gillick, VOICE CHOICES, Village Voice, December 1.
Ken Johnson, LIAM GILLICK, New York Times, December 8.

2001 SPEKULATIVE ARCHITEKTUR - LIAM GILLICK,
Neue Zürchner Zeitung, Jan 31.
Michael Archer, LIAM GILLICK, Art Forum, March.
Javier Hontoria, LIAM GILLICK, El Mundo-El Cultural, March 14.
Elizabeth Kley, LIAM GILLICK, Art News, April.
Paul Clark, LIAM GILLICK, Evening Standard, April 17
Various authors, Parkett 61.
Aeneas Bonner, QUANTUM MURALS ON ORMEAU ROAD, Irish News, April 28.
David Bussel, LIAM GILLICK, ID, May.
Matin Durrani, BELFAST CONFUSED BY MYSTERY QUESTIONS,
Physics World, June.
Sassa Trülzsch, DER GERISSENE FADEN: RHIZOM, Kunstforum, June/July.
Anjana Ahuja, TRY TO ANSWER THAT, MATE, The Times, June 4.
Annie Fletcher, VERWARRING ALS PRIMAIRE CONDITIE, Metropolis M, Aug-Sept.
Doris Krump, FREEJAZZ IN DER GRAUZONE, Der Standard, September 26,

A QUESTION. ANSWERS FROM, Frieze, November - December.
2002 Edgar Schmitz, LIAM GILLICK: ANNLEE YOU PROPOSES, Kunstforum, Jan-March.
Roberta Smith, THE ARMORY SHOW, GROWN UP AND IN LOVE WITH COLOR,
New York Times, Feb 22.
ANNLEE ET SES VIES, Kunst-Bulletin, No. 4.
Elizabeth Mahoney, SEA OF DREAMS, The Guardian, Feb 22.

SELECTED WRITING BY THE ARTIST

1988 GUNTHER FÖRG, New Art International, May.
1989 BETHAN HUWS, Art Monthly, Oct.
RICHARD WENTWORTH, New Art International, Oct.
ROBERT MANGOLD/BRUCE NAUMAN, Artscribe, Nov - Dec
MICHAEL CRAIG-MARTIN, Art Monthly, Dec - Jan
1990 ALLAN McCOLLUM, Artscribe, Summer.
CRITICAL DEMENTIA: THE BRITISH ART SHOW, Art Monthly, March.
PARIS - FRANCE, Art Monthly, September.
CONVERSATION WITH DAMIEN HIRST, Artscribe, Nov - Dec.
LES ATELIERS DU PARADISE, Artscribe, September.
1991 CONVERSATION WITH ERIC TRONCY, No Man's Time, CNAC, Nice.
JAMES COLEMAN, Artscribe, June.
GAMBLER, Building One, London.
LAWRENCE WEINER, Art Monthly, March.
THE PLACEBO EFFECT, Arts Magazine, May.
SIMON LINKE: A FUNNY THING HAPPENED ON THE WAY TO ARTFORUM,
Artscribe, summer
1992 REASONS TO LIKE THE WORK OF KAREN KILIMNIK, Documents, Issue 0.
RIDICULOUS JIMMY STEWART FILMS, Documents, Issue 0.
TRADING IMAGES, Exhibit A, Serpentine, Feb.
BETHAN HUWS/MAKING WORK, Parkett, summer.
Mike Kelley, Art Monthly, Jul - Aug.
THE BIBLE, THE COMPLETE WORKS OF SHAKESPEARE..., META 2, April.
1993 CURATING FOR PLEASURE AND PROFIT, Art Monthly, June
ERICSON & ZEIGLER, WSCAD Farnham, March
LANGLANDS & BELL, Museet for Samtidskunst, Oslo.
1994 WALL TO WALL, Southbank Centre, January.
A GUIDE TO VIDEO CONFERENCING SYSTEMS AND THE ROLE OF THE
BUILDING WORKER IN RELATION TO THE CONTEMPORARY ART EXHIBITION
(BACKSTAGE), Documents, No.4.
CONTEXT KUNSTLERS, Art Monthly, June.
LIAM GETS A SERIAL KILLER ANNOYED, Art & Text, Sept.
AUDIO ARTS, DISCOURSE AND..., Academy Editions, Sept.
FROM COATBRIDGE TO PIACENZA, CCA, Sept.
ZERYNTHIA, Fondazione Ratti, Sept. 1994
ARCHIVES & ATLASES, META 3, Dec.
LIKE SURE OR NOT, Paletten, Dec.
1995 IMPORTANT POSTMEN, Mobius Strip, Basilico Fine Arts, Jan.
WHEN ARE YOU LEAVING, Art & Design, Spring.
HENRY BOND & LIAM GILLICK, Camera Austria.
MISS ME: MICHAEL JOO, Art Monthly, April.
FORGET ABOUT THE BALL AND GET ON WITH THE GAME, (with Rirkrit Tiravanija),
Parkett 44, Summer.
GRIM, project with Douglas Gordon, Parkett 44, Summer.
JOHN BALDESSARI: I WILL NOT MAKE ANY MORE BORING ART, Art Monthly, Oct.
1996 FELIX GONZALEZ-TORRES, Art Monthly, March.
ANGELA BULLOCH: TURNING A CHAIR INTO A SWITCH, Documents.
THE CORRUPTION OF TIME, Flash Art, May/June.
L.Y.S.E.N.K.O., Glück, Carsten Höller, Oktagon.
1997 COMING TO TERMS WITH THE TERMS, Art Monthly.
ANDREAS SCHULZE: BETWEEN THE PARK AND THE HOUSE IS A ROAD,
Kunstverein Ludwigsburg.
PADRAIG TIMONEY: TAKING A BUBBLE TO THE TOP OF A MOUNTAIN,

Orchard Gallery, Derry.
SAILING ALONE AROUND THE WORLD, (with Douglas Gordon), Parkett, 44.
1998 PREVISION, Paris, ARC, Musée d'art moderne de la ville de Paris.
SO THERE ARE AT LEAST TWO TYPES OF LOBBY, Art & Text.
RICHARD DEACON: WHAT KIND OF SNOW IS THAT LAMP MADE FROM?
Tate Liverpool.
LOTHAR HEMPEL'S RIGGED ROOMS, Bureau Stedlijk, Amsterdam.
PUT YOUR FOOT DOWN, SYLVIE FLEURY'S PASSIONATE DISTANCE,
Le Magasin, Grenoble.
FIFTY FEET, TWENTY FIVE FEET, FIFTEEN FEET, Art/Text, Oct.
1999 TWENTY-FIVE YEARS: THE REMATERIALISATION OF THE ARTWORLD,
Art Monthly, Feb.
SHOULD THE FUTURE HELP THE PAST?, Afterall, Pilot Issue.
SPECULATION AND PLANNING, Art/Text, April.
SUSPENSION: one work by Marine Hugonnier, FRAC Montpelier.
IN THE BEGINNING THERE WAS NOTHING. AND THE LORD SAID 'LET THERE BE
LIGHT' AND THERE STILL NOTHING, BUT NOW YOU COULD SEE IT,
Power, Galerie für Zeitgenossische Kunst, Leipzig.
FEELING QUEASY, ALLEN RUPPERSBERG AND TOO MANY BOOKS AND TOO
MUCH COFFEE, JRP Editions, Geneva.
2000 EXTERIOR: DAY PIERRE HUYGUE AND THE ROLE OF THE IMPLICATED PLAYER,
Le Consortium, Dijon
FROM QUEBEC 1907 TO STOCKHOLM 2000 WHAT IF/TÅNK OM,
Moderna Museet, Stockholm.
THE ONLY ALTERNATIVE TO CRITICISM IS ART, Art Monthly.
REFRAMING THE NEW FUTURE, Frankfurter Allegemeine.
EASTWORLD, XAVIER VEILHAN'S MIRRORED CONTEXT,
Le Magasin, Grenoble.
2001 DO AMMONIA GAS FROZEN FRIES GO WITH THAT SHAKE? JOHN MILLAR,
Art Monthly, Sept.
STYLE AND COUNCIL: CERITH WYN EVANS AND THE DEVASTATION OF
MEANING, Afterall.
2002 PEASANT UPRISINGS IN SEVENTEENTH CENTURY FRANCE, RUSSIA AND
CHINA: BARABARA KRUGER AND THE DE-LAMINATION OF SIGNS, Afterall.